modern
brush
lettering

A beginner's guide to the art of brush lettering,
plus 20 seasonal projects to make

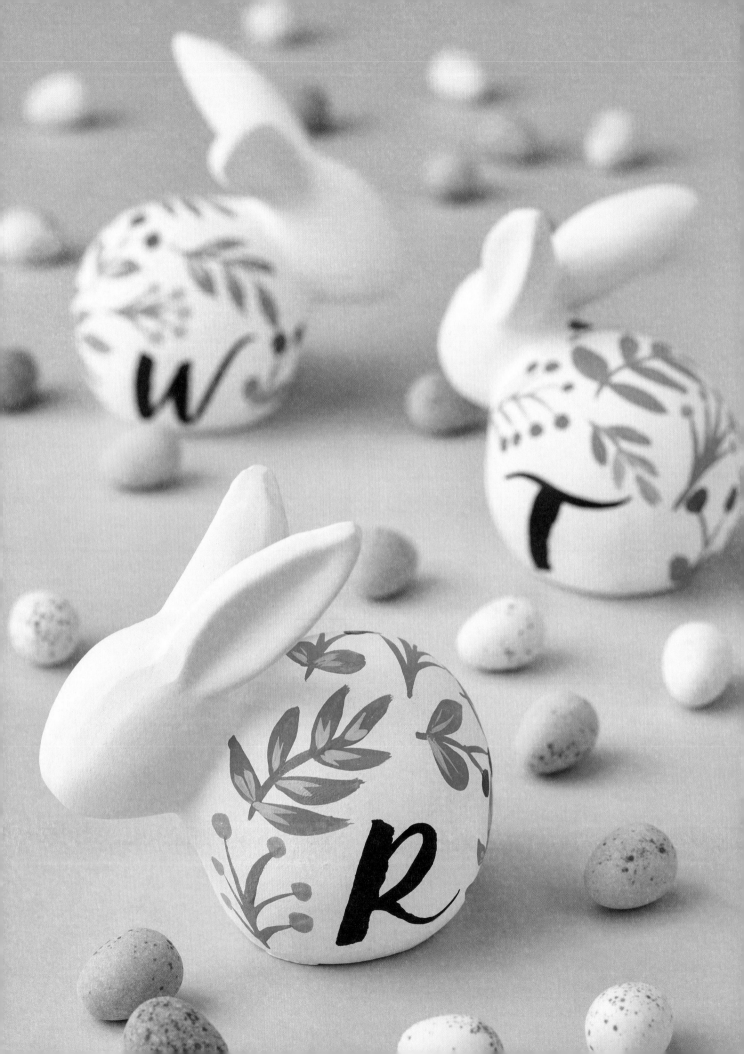

modern
brush
lettering

A beginner's guide to the art of brush lettering,
plus 20 seasonal projects to make

BECKI CLARK

*Photographs by Jesse Wild
and Becki Clark*

WHITE OWL

For my lovely Mama, whose creativity has forever inspired me and who has always encouraged me to do what makes me happy.

First published in Great Britain in 2020 by
PEN & SWORD WHITE OWL
An imprint of Pen & Sword Books Ltd
Yorkshire – Philadelphia

ISBN 9781526747358

Group Publisher: Jonathan Wright
Series Editor and Publishing Consultant: Katherine Raderecht
Art Director: Jane Toft
Editor: Katherine Raderecht
Photography: Becki Clark and Jesse Wild

Printed and bound in India, by Replika Press Pvt. Ltd.

Pen & Sword Books Ltd incorporates the Imprints of Pen & Sword Books
Archaeology, Atlas, Aviation, Battleground, Discovery, Family History, History, Maritime, Military, Naval, Politics, Railways, Select, Transport, True Crime, Fiction, Frontline Books, Leo Cooper, Praetorian Press, Seaforth Publishing, Wharncliffe and White Owl.

For a complete list of Pen & Sword titles please contact:

PEN & SWORD BOOKS LIMITED
47 Church Street, Barnsley, South Yorkshire S70 2AS, England
E-mail: enquiries@pen-and-sword.co.uk
Website: www.pen-and-sword.co.uk
or
PEN AND SWORD BOOKS
1950 Lawrence Rd, Havertown, PA 19083, USA
E-mail: Uspen-and-sword@casematepublishers.com
Website: www.penandswordbooks.com

contents

introduction

I've always had an interest in lettering. When I was a child I had different styles of handwriting that I used for different subjects. My teachers found it quite annoying and asked me if I could choose just one style to write in rather than constantly changing my handwriting throughout the year. It wasn't until I studied design at university that I realised there was a world of hand lettering out there.

After I graduated, I worked as a greetings card designer and started to experiment with different ways to create phrases and slogans for cards. It was in this first job that I first discovered brush lettering. It wasn't as popular then as it is now but I found lots of YouTube tutorial videos and taught myself the basics. Up until this point, I had been creating a brush lettering effect by using an ink pen to draw calligraphy letters and then fill them in. When I discovered brush pens, my whole approach to lettering changed; brush pens gave me the colour versatility and brush stroke thickness I was looking for and helped evolve my lettering style. I began selling my prints and eventually I launched my own wedding stationery company, Olive and Bramble, where I create brush lettering invitations, place settings and signage. I even hand-lettered craft beer cans for one couple!

I've always had an interest in craft as well as graphic design. From a young age, I loved to spend my days making and creating things. A couple of years ago I was approached by a magazine to create a tutorial combining brush lettering and craft. This was a light bulb moment for me! I realised brush lettering wasn't just for paper and stationery but could be used on a variety of mediums to create gifts and homewares.

From that time there was no stopping me. In 2015 I began teaching brush lettering workshops. I love getting to spend time teaching my passion. The joy of people learning something new in just a couple of hours is one of the highlights of my career. In the past few years I have worked for a variety of brands including Mollie Makes, Hobbycraft, Homesense and The Handmade Festival, teaching workshops to groups of keen learners. I have also worked on logos for branding, editorial lettering for magazines,

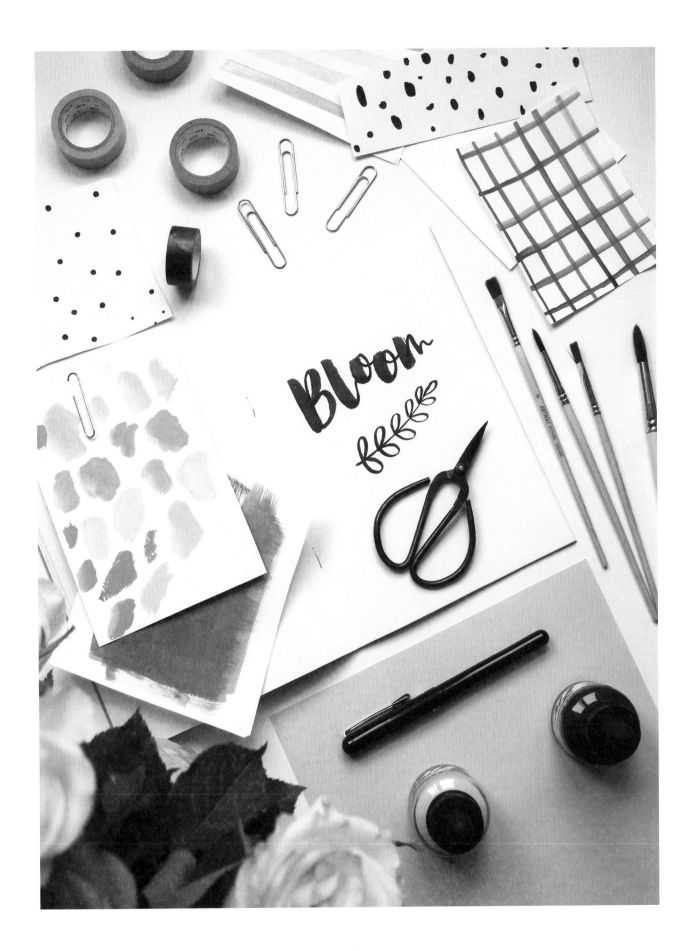

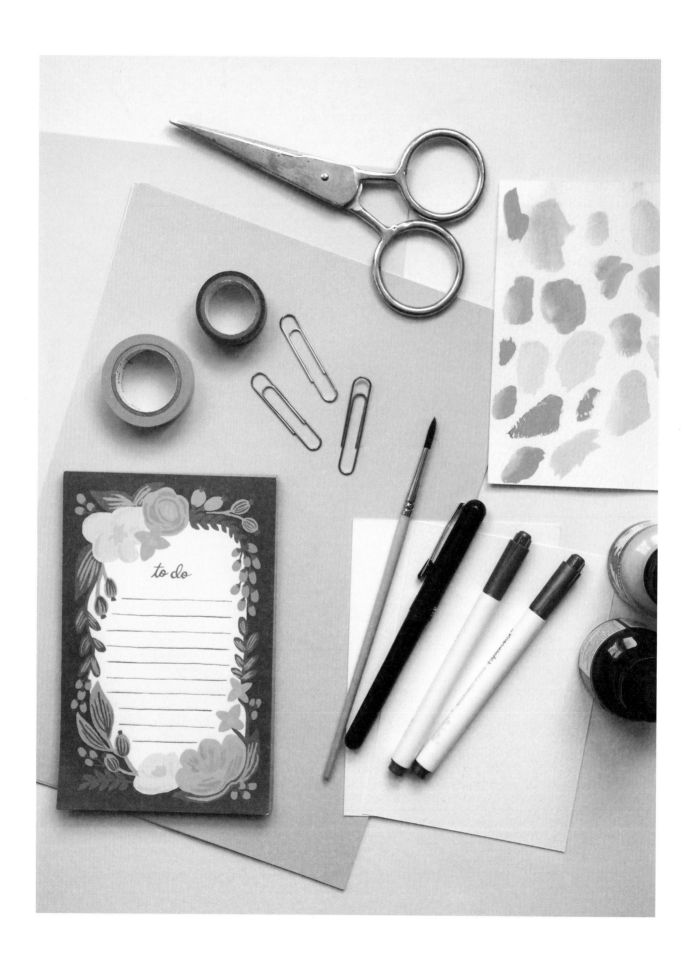

and craft tutorials - all using brush lettering. I am confident that anyone can learn the art of brush lettering. With perseverance and practice, and a pen in your hand, the world is your oyster!

WHAT IS BRUSH LETTERING?

Brush lettering is a style of hand lettering formed from a mix of stroke thicknesses created by a brush. It differs from calligraphy as there are less rules about forming the letters; the process is more about drawing the letters. It is something anyone can learn and, as a result, has become a popular style for creating stationery and homewares. You don't need to have 'good handwriting' or any previous experience with calligraphy. Brush lettering is simply about learning the techniques and then practice until you create your own unique style of brush lettering.

HOW TO USE THIS BOOK

One of the hardest things about learning something new is starting. There have been countless times when I've bought a book to learn a new craft, only for it to sit on my bookshelf untouched for months. I don't want that to happen with my book! I want to encourage you to pick up a pen and just have fun.

We'll begin by working through the basics mark making, the start point for anyone who wants to learn brush lettering. This will teach you the basic techniques you'll need when moving on to lettering your first alphabet. In the alphabet section you will find two different alphabets to practice lettering. We will then move on to joining letters to create words. I've given you some practice phrases to copy to help build your confidence.

Once you've mastered the basic technique, you can start brush lettering on all sorts of different things. You'll find lots of seasonal projects to make, from spring right through to winter. I hope these projects inspire you to get creative with your lettering and maybe spark some new ideas for other craft projects! I really hope you enjoy the process of working through this book, discovering your own style and creating your own beautiful brush lettering.

Now lets get started...

chapter one: tools

You don't need much to get started but it is really important to use the right tools. Investing in a good brush lettering pen and a pad of smooth paper is a good place to start on your brush lettering journey.

BRUSH LETTERING PENS

The great thing about brush lettering is that it doesn't require lots of specialist equipment to get started. You simply need a pen and paper. There are hundreds of brush lettering pens on the market and everyone has their own favourite: I love to use the Pentel Brush pen. I found it a couple of years ago before it was marketed specifically for brush lettering and have never looked back! What I love about this pen is it has a really flexible brush tip; it's like a paint brush so it responds really well to pressure and allows you to create different stroke thicknesses easily. It's definitely a good buy if you are completely new to brush lettering. If you already have your own pens that's fine - you can work through the book with those.

As the name implies, you can also use a paint brush and ink for brush lettering. You need to choose a mid-size paint brush, but just make sure it is in perfect condition with no loose bristles which will create blemishes on your lettering. If you want to use ink, I think the best make is the classic Windsor & Newton Indian ink. Be careful with using a brush and ink as it can create a messy look if you use too much or, of course, accidentally knock it over!

Pentel Aquash waterbrush pens are also great to try with coloured paints to create an ombré lettering effect. Waterbrush pens have a hollow body, which is filled with water or colour, and a flexible brush tip. They work just like a paint brush and are good investment if you want to add colour to your lettering!

For most of the projects in the book, I have used my Pentel Brush pen. On some of the more detailed projects where I have wanted to showcase colour or metallic effects, I have used Docrafts permanent markers and Papermania metallic pens. Where I have used specialist pens, I have noted them in the materials list for each project. Don't worry, though, to work through the initial exercises and practice sheets you will just need a standard brush pen and paper.

PAPER AND CARD

Although you can use any paper for brush lettering I find a smooth 90gsm paper works best. If there is too much grain in the paper your pen strokes can start to look a bit wobbly. Conversely, if the paper has a gloss or silk finish, the ink won't adhere properly to the surface. The paper pad I use most is a mixed media, layout or drawing pad from Hobbycraft. These pads are perfect because the paper textures work well with ink and the paper is thin enough for you to trace letters and designs if you want to.

When it comes to card, I would advise a 300gsm silk card, which is best for a smooth lettering finish but thick enough to create the quality feel of a gift card.

You may also want to have a pencil to hand. In some projects I have suggested you use a pencil to rough out your lettering before working over it with your brush lettering pen. Any artist's pencil will work well. You will also need a soft rubber to erase your pencil marks after you've finished.

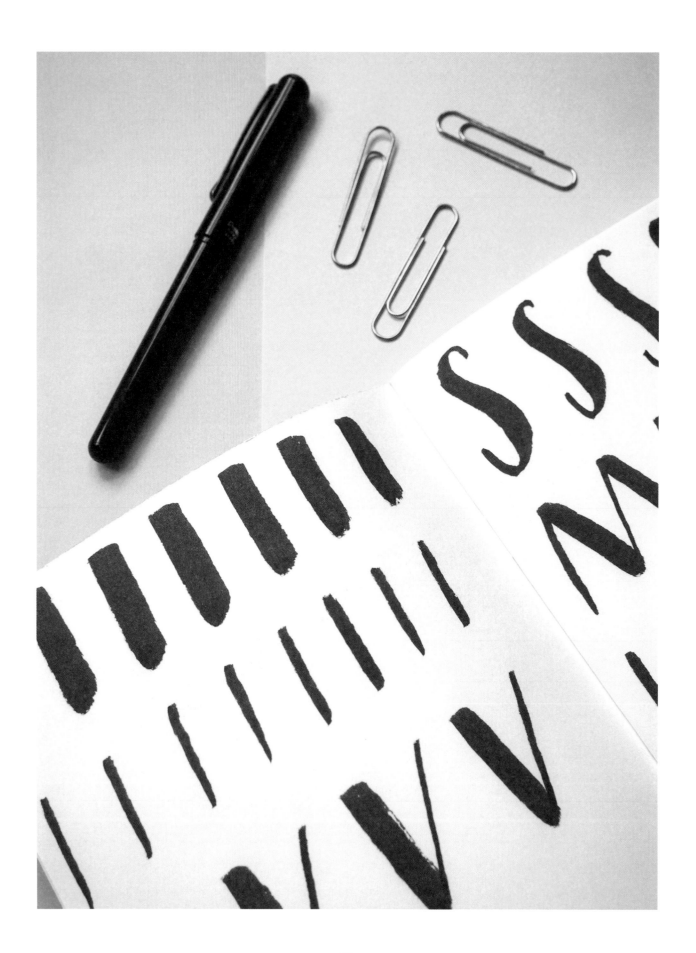

chapter two: mark making

Mark making is a really important exercise before you start lettering. It's a good way to explore the way your pen works and looks on the page and is also a great way to get in the swing of creating thick and thin strokes

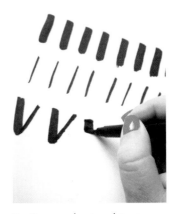

Don't worry about applying too much pressure or your strokes looking too thick. It's easier to create a really good contrast in your lettering if you can create lovely thick strokes.

Once you have decided which pen to use you can begin exploring mark making. The principles of these exercises work with any pen or brush but I have created them using the Pentel brush pen. I would also advise that you work on plain paper. Brush lettering is creative and although you may think working on lined or graph paper will help you, your lettering needs to be free and creative so the fewer restrictions the better.

HOLDING YOUR PEN
You will probably find your natural inclination is to hold the pen upright as you would when writing normally. However, to get a good contrast in stroke thickness, you should hold your pen slightly to the side so that on the downward stroke you can create the maximum thickness from the brush. People often ask if its easier to hold the pen closer to the brush end, but my advice is to hold it where you would naturally hold a normal writing pen, as this will feel most comfortable.

MARKS AND PRESSURE
Working through these mark making exercises will get you used to using your pen. You will also learn how much pressure you need to apply and discover how different pressures create different effects. This will help you get ready to start creating your lettering. Whenever I start a new lettering project, I still make a sheet of marks to get my hand used to my pen and get back into the swing of lettering. With these exercises, we will focus on making a few different marks, which will help you progress to lettering your first alphabet.

MARK 1 – THICK DOWNWARD STROKES

Begin by making thick downward strokes. Apply continuous pressure during the whole stroke. When you reach the bottom, take the brush off the paper in one go so that you don't create an uneven bottom to your letter. Remember to keep your hand slightly tilted to the side to ensure you use the full thickness of the pen on the downward stroke. Don't worry about all your letters looking the same - these are just exercises to get you used to using the pen. Work across the page creating these thick downward strokes until you feel confident with them.

MARK 2 – THIN STROKES UPWARDS

Now try lettering thin upward strokes. By using just the tip of the pen and a lot less pressure you will create thin lines. Take your time and move your hand across the page at about half the speed of your normal handwriting. Don't worry if your lines are slightly wobbly; you have only just begun and it takes a while for you to get used to the pressure of the pen. Again, work across the page creating thin upward strokes until you feel confident.

MARK 3 – THICK STROKE DOWNWARDS WITH A THIN STROKE UPWARDS

The next mark to try is a thick stroke downwards followed by a thin stroke upwards to create a V shape. When you are nearing the end of the thick downward stroke begin turning the pen. You won't have to do too much work as the brush should respond to the pressure and turn easily. You can then draw your thin stroke upwards. Try and draw the line continuously but it's

fine to take a break when you get to the bottom of the thick line. Remember these aren't rules, so if you feel more comfortable taking a break between strokes then go for it.

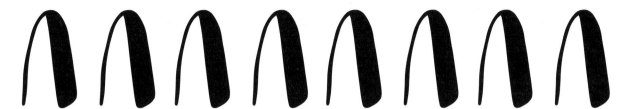

MARK 4 – THIN STROKE UPWARDS WITH A THICK STROKE DOWNWARDS
Now it's time to draw a thin stroke upwards with a thick stroke downwards. This shape has a slightly more curved top which gives you a chance to practice increasing your pressure from the thinner stroke to the thicker stroke on the way down.

MARK 5 – THIN STROKE UPWARDS, THICK STROKE DOWN AND THIN UPWARD
This shape will help you to get used to creating different stoke sizes in succession. Work across the page until you feel confident. Remember to create a flow to your lettering. If you feel your hand getting tense, let go of the pen, shake your hands and start again.

MARK 6 – Although this next mark looks like an 's' it is a mark designed to help you get used to creating small curves with contrasting strokes, so don't try and make an 's' shape. You need to focus on the different strokes and getting the lines close to each other. Take your time with this mark; it is one of the harder ones. Create a thin curve and just as you turn the pen you should apply more pressure to get a thicker downward stroke. Then as you get to the bottom reduce the pressure for the bottom curve.

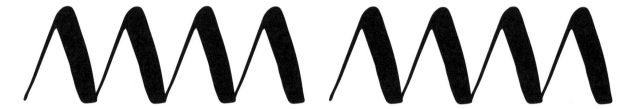

MARK 7 – The next mark to make is a continuous line of thick and thin strokes - almost like drawing a mountain range. This will get you used to working across the page continuously ready for when you start working on longer words and sentences. If you have been finding it hard to keep your pen on the page during mark making this is a really good technique to help you practice. You can also experiment with elongating lines, as each line doesn't have to be exactly the same length.

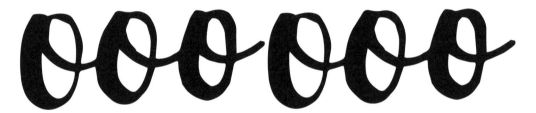

MARK 8 – This mark is about creating continuous circles to get you used to creating different strokes on curved lines ready to join a another letter. If you find it hard to create this mark in one motion then just take it stroke by stroke so that you can take your pen off the page.

MARK 9 – Our final mark is created by working across the page downwards applying different pressures. It will help you to get used to curves and continuous line work. Don't worry though; no letter in the alphabet will require this many twists and turns to create!

All the shapes you have created and the techniques you have used to make these marks will now help you with the next stage - lettering the alphabet. If you think of the letters of the alphabet as just shapes made up of marks, it will feel less daunting. The more confident you feel with mark making the easier you will find turning the marks into letters.

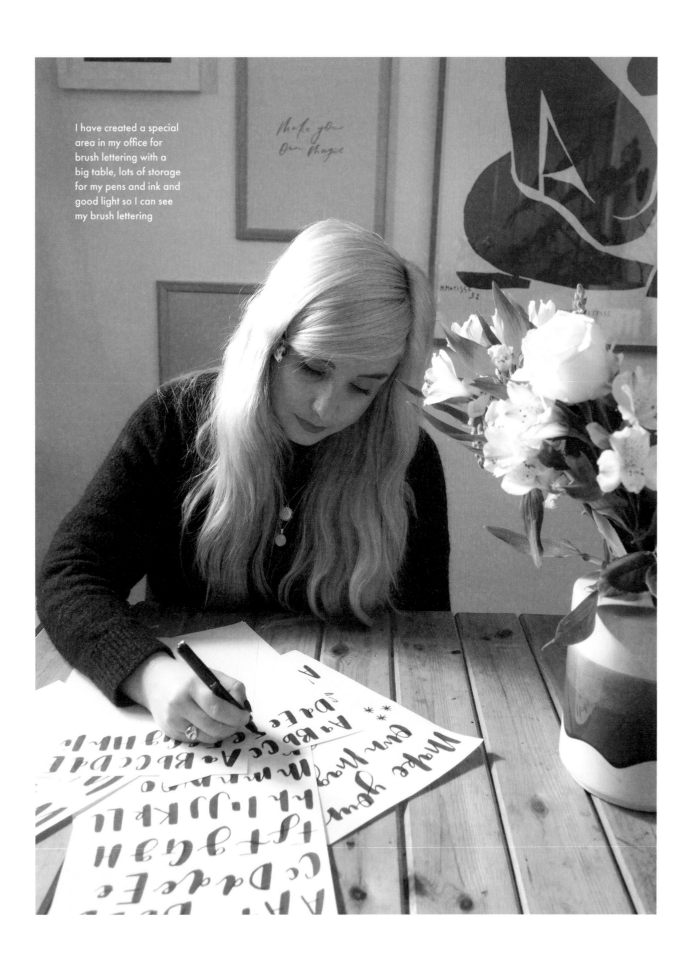

I have created a special area in my office for brush lettering with a big table, lots of storage for my pens and ink and good light so I can see my brush lettering

chapter three: alphabets

Working on your alphabet may seem overwhelming but just keep in mind that each of the letter forms are just made of marks; its just a case of breaking down the letter forms to make them as easy as possible.

BECKI'S TIPS

■ Don't hold your pen too tightly. Just check you have a nice relaxed grip.

■ Make sure your ink is full. You will know when you are running low on ink because your lines will start to look thin and spidery on the page.

■ If you are having trouble with the alphabets, trace over my lettering to build up your confidence.

■ Don't be afraid to apply pressure on your pen; all good brush lettering pens are built for a mixture of pressures.

THE BRUSH LETTERING ALPHABET

Now you have mastered mark making, its time to turn your marks into letters. Don't be daunted by this stage. A really good trick is to break each letter of the alphabet down into individual brush strokes. You also need to follow the general rule that downward brush strokes are thick and upward brush strokes are thin. However, there are exceptions to this rule, and letters need contrast between thick and thin to work in brush lettering. A capital 'A', for example, would look too heavy if it consisted of two thick downward strokes. As you can see on the example alphabet opposite, having a thick and a thin downward stroke on the 'A' looks much more pleasing.

If you don't feel confident keeping your pen on the page for the whole letter form, then take it step-by-step making each individual stroke to create the finished letter. This first alphabet showcases the most simple style of brush lettering, with well proportioned letters made up of an even mix of thick and thin strokes.

There will probably be a few letters you find easier to master lettering than others. Have a look at the alphabet and find other similarly shaped letters to the ones you find easiest and work on them as a group. The more you practice, the easier it will be when you start creating words from the individual letters of the alphabet.

Aa Bb Cc Dd Ee
Ff Gg Hh Ii Jj
Kk Ll Mm Nn Oo
Pp Qq Rr Ss Tt
Uu Vv Ww
Xx Yy Zz

Aa Bb Cc Dd Ee
Ff Gg Hh Ii Jj
Kk Ll Mm Nn Oo
Pp Qq Rr Ss Tt
Uu Vv Ww Xx
Yy Zz

THE ITALIC BRUSH LETTERING ALPHABET

If your natural handwriting style is italic you will probably find it a lot easier to brush letter with a slight slant too. The alphabet opposite uses the same principles as the previous alphabet - it is just a sloping version of the style with less exaggerated thick and thin strokes. If you don't usually write in italic handwriting you can still experiment with this alphabet; it's all about finding out what works best for you and how you want your lettering to look.

JOINING YOUR LETTERS TOGETHER

You don't have to join individual letters together in brush lettering; however, connecting the letters together creates movement and style. It will also make your brush lettering look more dynamic and fluid. To start, if you want to create a joined up look to your lettering, I suggest giving each of your letters tails. You can then use these tails to join your letters together.

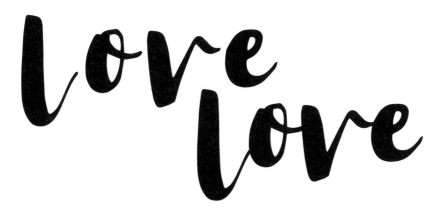

The example above shows the individual letters of the word 'love'. Each letter has a tail added. You can see if you nudged all the letters closer together, your lettering would appear joined up. To begin with, this is a really easy way of creating the effect of joined up brush lettering without having to keep your pen on the page the whole time. As you begin to feel more confident you will be able to use your tails to link the next letter as you write.

Try some of the phrases on the following pages. Give each letter a tail and take a break between each letter to gain confidence in joining your lettering.

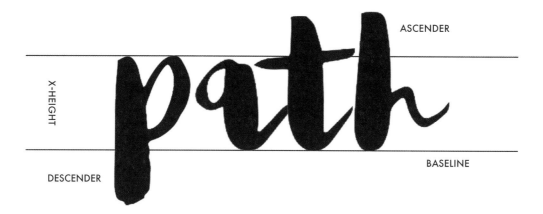

ASCENDER

X-HEIGHT

BASELINE

DESCENDER

LETTER PROPORTIONS

The baseline is the invisible line that the bottom of your letters sit on. The x-height refers to the distance between the baseline and the top of the main body of a lower case letter (imagine a lower case 'a' sitting on your baseline - the distance from the bottom to the top of the letter is the x-height). Ascenders are the vertical strokes that extend above the x-height line like on the letters 'b' or 'f'. Descenders are the vertical strokes that extend below the baseline like on the letters 'g' or 'p'. Ascenders and descenders give you the chance to add personality to your brush lettering. You may naturally add curved touches to letters such as 'g' and 'y', but its worth experimenting with different ascender and descender flourishes to see what works best in your particular style of lettering.

NUMBERS AND SYMBOLS

The same technique for creating letters also applies to creating numbers and symbols. Apply more pressure on the downward strokes to create thicker lines and less pressure on the upward strokes to create thinner lines. Practice the numbers and symbols opposite, breaking the shapes down into individual strokes to make them easier to letter.

CREATING YOUR OWN STYLE

As you begin to feel more confident with these alphabets, you can experiment with elongating some of the letters and starting to create your own style. I have taught people who love to keep their lettering size neat and perfectly proportioned, whilst other students love to elongate their letters, add extra flourishes and create a wilder look. My advice is to work with the style you feel most comfortable with and develop that. Don't try to copy anyone else's style. The wonderful thing about brush lettering is that everyone has their own unique look.

Remember, too, that practice makes perfect. Your lettering will develop and grow over time and the more you practice the better your results will be. Brush lettering takes commitment but the results will be well worth it!

1 2 3 4 5

6 7 8 9 0

? ! @ /

& £ * %

+ = & ;

With love
on your
birthday

only
you

Always
you

just for
you!

With
love

Lets
party

With love

chapter four: practice phrases

Spend time perfecting your brush lettering techniques with these practice phrases and you'll soon feel confident enough to letter your own words. I've chosen some useful sayings I use again and again in my cards and stationery.

BECKI'S TIPS

■ Cushion your paper by putting a few sheets of newspaper underneath it.

■ Sit comfortably with your back straight and give yourself plenty of space to spread your arms out while you letter.

■ Embrace your lettering quirks and make them part of your own unique style.

In this chapter, you'll find some phrases to practice your lettering on. With these example phrases, I've aimed to show you the different ways that letters can sit next to each other. You don't need to worry too much about your letters looking exactly the same; they can be bigger or smaller depending on the other letters in the word. If you have two of the same letter next to each other, aim to make the two letters different sizes. This will stop them looking flat on the page and give your word movement.

The phrase 'with love' is good for practicing creating a looser look to your lettering. Get the letters sitting at alternate heights in each word. Focus on adding character to your lettering. When you write 'lets party' think about the meaning of the phrase and try to add fun and movement to the letters 't' and 'y'.

COMPOSITION

When you start working on brush lettering projects it is important to consider the layout and composition of the finished piece. A layout for a large print for your home will be different to a layout for a set of children's party invitations.

The most important thing to focus on is the vertical and horizontal spacing between the words. For instance, if you are designing a birthday card using a long greeting like 'with love on your birthday' you first need to consider how many lines you are going to letter the text across. You want the lettering to fill the space, but also to look balanced and have enough room to breathe. You don't want your letters to be competing or fighting with one another; they need to work together in harmony.

You don't have to keep your words separate. Take a look at the 'always you' phrase. You can see the 'you' slots neatly into the space underneath the 'always' which makes the phrase look more considered. Always look for chances where you can do this!

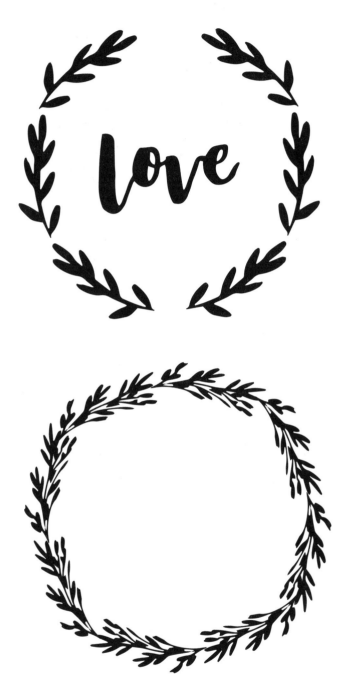

FLOURISHES AND ILLUSTRATIVE ELEMENTS

Adding in flourishes or frames can help a design to come to life. Here the word 'love' has been lettered horizontally across the page and then the flourish drawn around it to frame it. This foliage flourish can be made using your brush lettering pen. Firstly mark the centre of the word, draw a curved line from this point around the right hand side of the word and then add teardrop shapes to create the leaves. Now repeat this on the left hand side, making sure your foliage looks even on both sides.

This festive wreath shape is created by drawing a rough circle using thin brush strokes before adding small leaves randomly around the inside and outside of the circle. Don't worry about the leaves all being exactly the same size; nothing in nature is uniform and irregular sized leaves gives your wreath a pretty handmade feel.

Moon and star shapes are simple motifs you can draw with simple stroke lines and then fill with ink or leave empty.

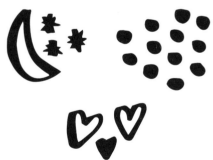

Hearts are another simple decorative shape. You can letter inside the heart or use a group of hearts around your lettering. Polka dots are simple to make using the tip of your brush lettering pen. Again, you can fill in the circles or just leave them as shapes.

tis the Season

joy

Snow day!

Holly jolly

Christmas Cheer

chapter five: mindfulness

Although you may think mindfulness means being still, it can actually be anything that helps you embrace being in the moment. Making and creating with brush lettering is a great way to tap into your own creative peace.

There have been a few times in my life when I've felt stressed out and overwhelmed. After a few days mulling over these feelings, I often find myself going to pick up a pen and paper and suddenly my mood has lifted. I feel brighter, time has flown by and I have usually (not always!) created something pretty with my brush.

FINDING JOY IN THE PROCESS
The repetitive strokes required for brush lettering really focus your concentration on the task in hand, letting you simply lose yourself in the moment. There is a real joy in the process of brush lettering, rather than the finished result, and that makes it such a fulfilling pastime. Seeing your perseverance pay off when you see the improvements on your sheets of practice marks or phrases can be so rewarding. Keep your practice sheets in a folder and keep them safe. They are great to look back on. I have some of my sheets from over 5 years ago!

MAKING AND CREATING
Many of my workshops begin with us all chatting excitedly, but as soon as we begin the lettering exercises the noise volume lowers and everyone can be found working in their own quiet space. Often a couple of hours have passed and my students say they feel so relaxed they don't know where the time has gone! I find brush lettering really helps to take your mind off the daily hustle and bustle, and quieten the noise in your head.

CELEBRATE THE SEASONS
Finding joy in the natural world brings fresh inspiration to my lettering. All the projects in this book celebrate the changing seasons. I hope you enjoy making them as much as I enjoyed creating them. I find crafting is such a great way to stay mindful and present throughout the year. For me, spring and summer mean an abundance of flowers, fresh starts, long evenings and bright colours - great sources of inspiration for my personal style of crafting. When autumn is on its way I find inspiration in the colours changing outside and I embrace the feeling of slowing down ready for winter. I know some people find winter, with its darker days and colder weather, makes being creative more of a challenge. However if you embrace the long winter nights and find joy in the Christmas season, you'll find its one of the best times to show off your new brush lettering skills with unique handmade gifts, wrapping paper and one-of-a-kind table decorations!

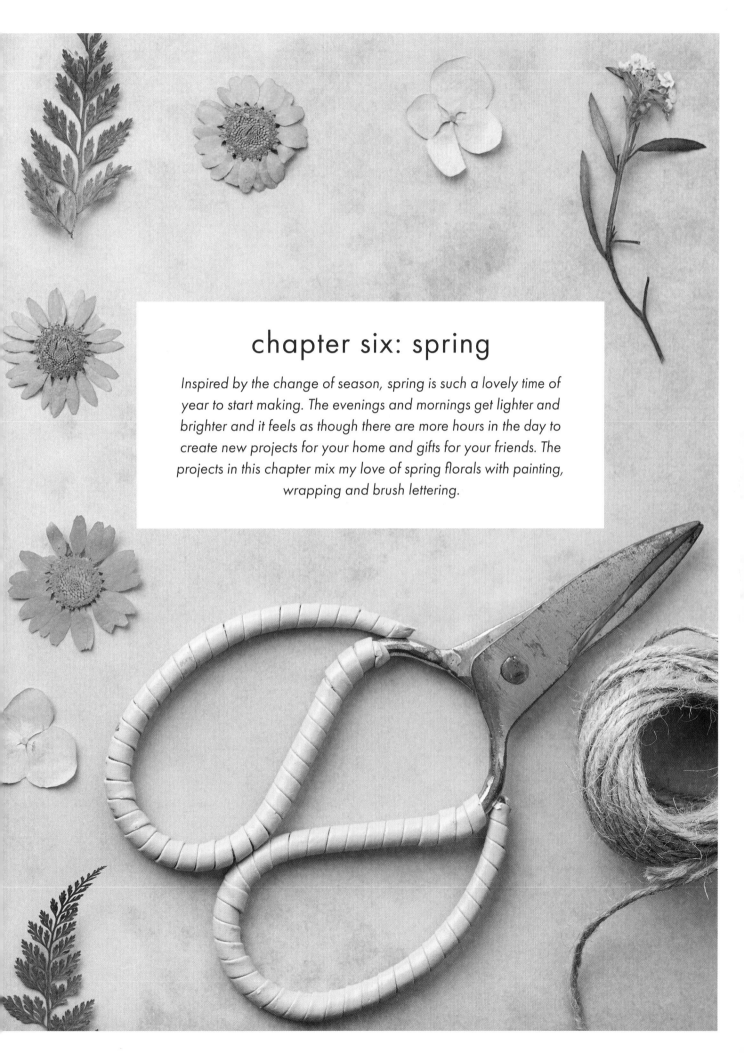

chapter six: spring

Inspired by the change of season, spring is such a lovely time of year to start making. The evenings and mornings get lighter and brighter and it feels as though there are more hours in the day to create new projects for your home and gifts for your friends. The projects in this chapter mix my love of spring florals with painting, wrapping and brush lettering.

Bloom
+
Grow

bloom and grow print

Creating artwork for your home is an easy way to make an individual design statement. If you have a friend's birthday coming up then a brush lettered print also makes the perfect handmade gift. The great thing about prints is they only require simple materials to make, yet they have the maximum impact!

Materials:
- Card
- Pencil
- Ruler
- Brush lettering pen

BECKI'S TIPS

- When deciding on your phrase have a think about how your letters will look together. You can see on the word 'bloom' opposite, I have made the two o's different sizes to give the words some movement rather than looking static.

- If you want to include colour in your print then plan out your palette before beginning. Ideally you want to keep to a minimal palette of just a few colours to make the print look stylised. Too many different colours will distract from your beautiful brush lettering.

- Think outside the box when it comes to framing. Display your artwork on a clipboard or just stick it on the wall with washi tape.

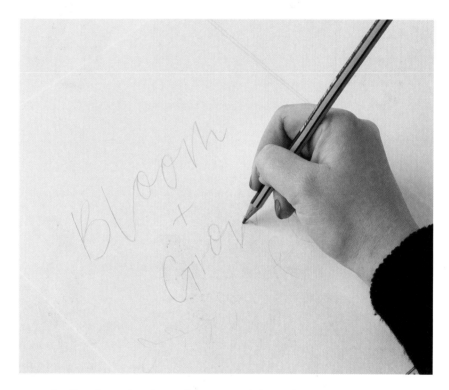

1. Firstly, decide on the phrase that you want to letter. Keep in mind the size of the card that you have to work with. For example, if you want to letter one word such as 'smile' or 'happy', use an A5 piece of card so your lettering won't get lost on the page. To start, it's easier to try and make your letters slightly bigger than your normal handwriting. As you become more confident you can experiment with larger letters.

2. I've decided to letter 'bloom & grow'. Because there are three words it will sit nicely on three lines of A4.

3. Mark where the centre of the page is to give you an idea of where your '&' should sit.

4. If you don't feel confident about lettering straight on to the card, you can use a pencil to sketch out the position of your lettering.

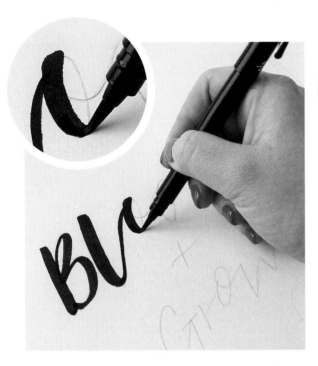

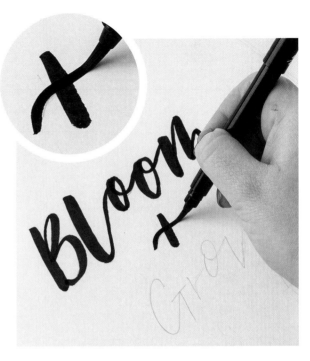

5. Once you are happy with your pencil marks, begin working over them with the brush lettering pen.

6. Sometimes its easier to get a smooth result if you take a break every couple of letters.

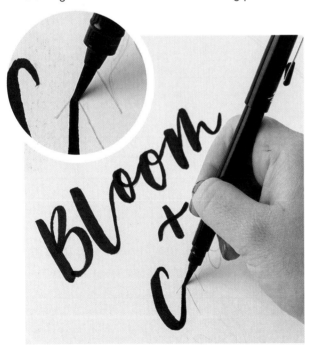

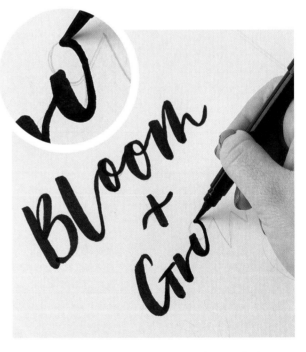

7. If it's easier, break your letters into strokes rather than drawing the whole letter at once.

8. You can add tails to your letters afterwards if you find it easier than lettering in one go.

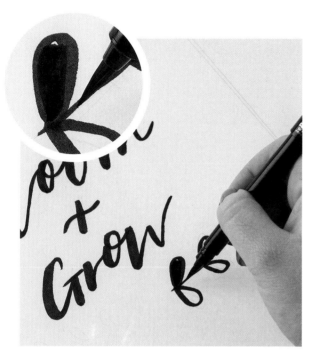

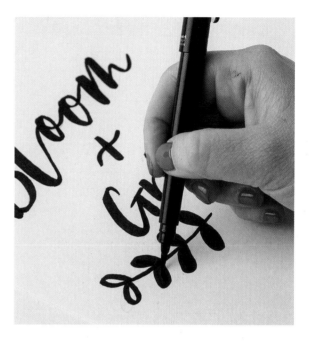

9. You can then add some foliage designs at the bottom of the print to frame your lettering. Use a pencil to sketch these out first if that makes it easier.

10. The foliage can be created by drawing a curved line for a stem with the brush pen and then drawing teardrop shapes to create the leaf shapes.

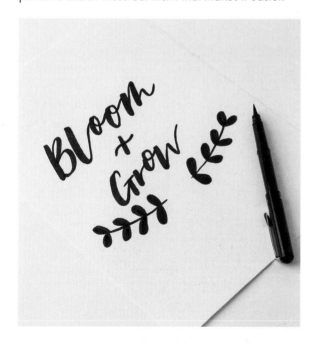

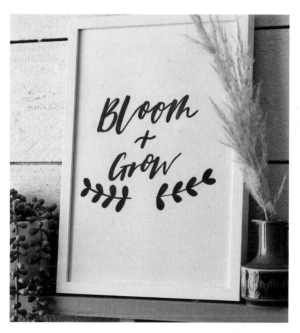

11. Leave your print to dry and that's it! You have some new artwork for your home.

12. If you feel your lettering is too small on the card, simply cut down the card down to make a mini print!

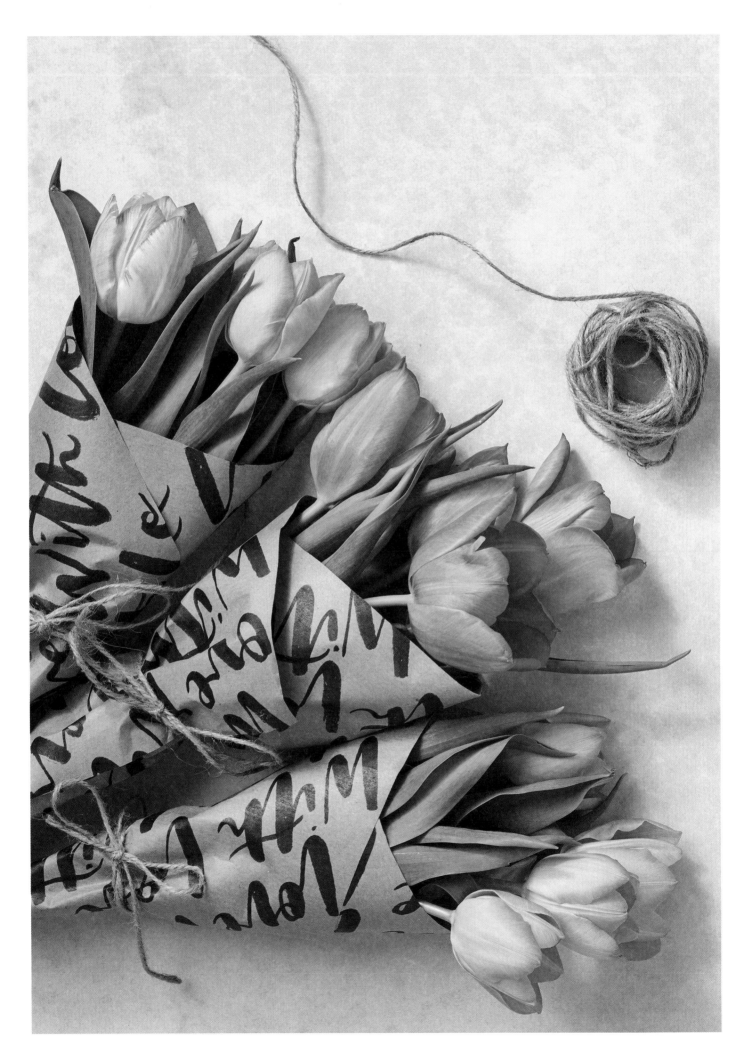

spring posies

Spring blooms are full of joy! I love having vases filled with flowers around the house. I also love to take a bunch of flowers as a gift when I visit a friend or attend a special event. This simple project is an easy way to turn brown paper from rustic to handmade gold!

Materials:

- Kraft brown wrapping paper
- Pencil
- Twine
- Washi tape
- Brush lettering pen

BECKI'S TIPS

- Make sure the stems of your flowers are dry before wrapping them in paper to stop the paper getting wet and spoiling your lettering.

- If you find the wrap is too small for the flowers then cut off the bottom. It is better to have too much paper than too little.

- You could use a coloured ribbon or wool instead of twine.

- If you don't have time to hand letter the whole sheet, just space out the phrases and dot them randomly over the wrapping project.

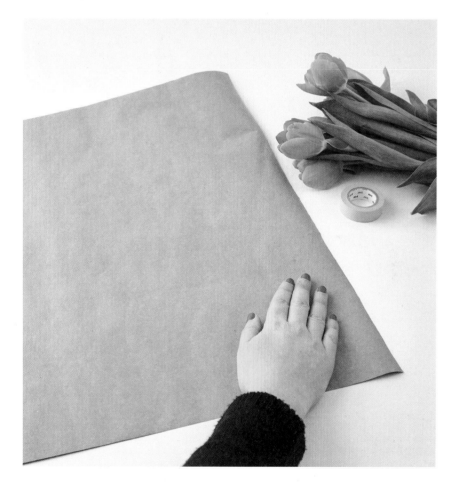

There are lots of occasions during spring where a bunch of flowers would make the perfect gift. From Mother's Day to Easter, this posy project will spread springtime joy. You can also adapt the idea to make your own wrapping paper. Use any material to tie the posy - it's a great way to use up your stash of materials.

1. Cut your paper into a square. I cut mine to a 50cm x 50cm size.

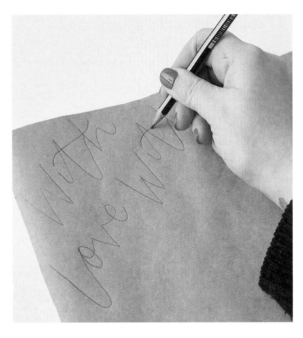

2. Lay your paper flat and begin pencilling your phrase across the paper. 'with love' is a great phrase to try as it has interesting flourishes on the letters.

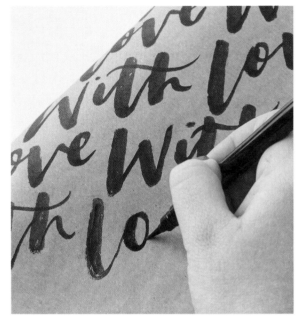

3. Protect the surface you are lettering on from ink marks by putting an extra piece of paper under your wrapping paper.

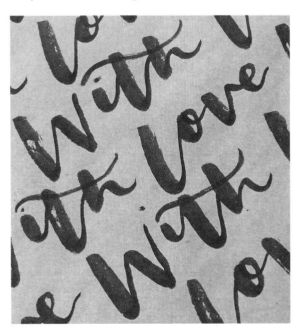

4. Take your time and once you are happy with your pencil lines use your brush pen to letter over them.

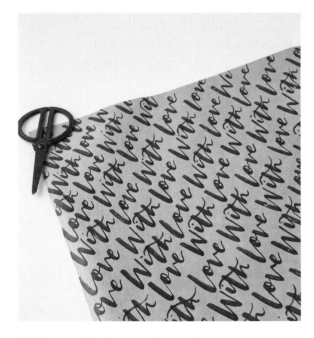

5. When you're happy with your design, you can scan it to your computer and print more copies.

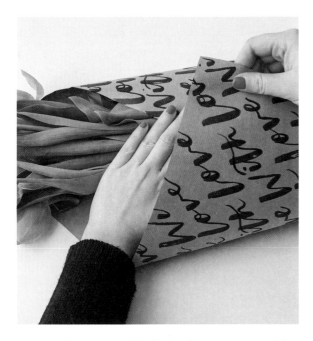

6. Once the paper is fully lettered, wrap it around the blooms and use washi tape to secure it.

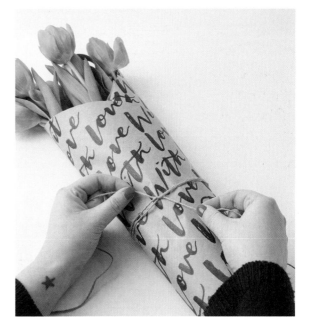

7. Cut a length of twine and tie it around the bouquet pulling it tightly into a knot.

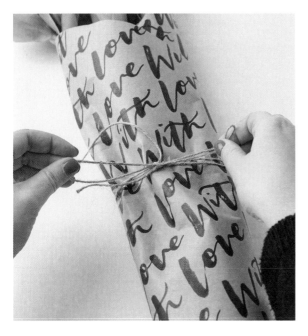

8. Make sure you wrap the twine around a few times to ensure it stays in place before tying a knot.

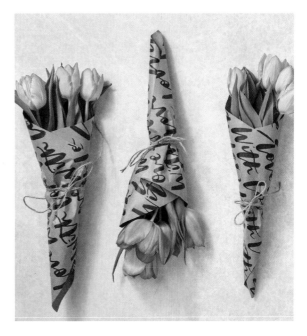

9. These bouquets would make the perfect gift for friends' birthdays, Mother's Day or Easter!

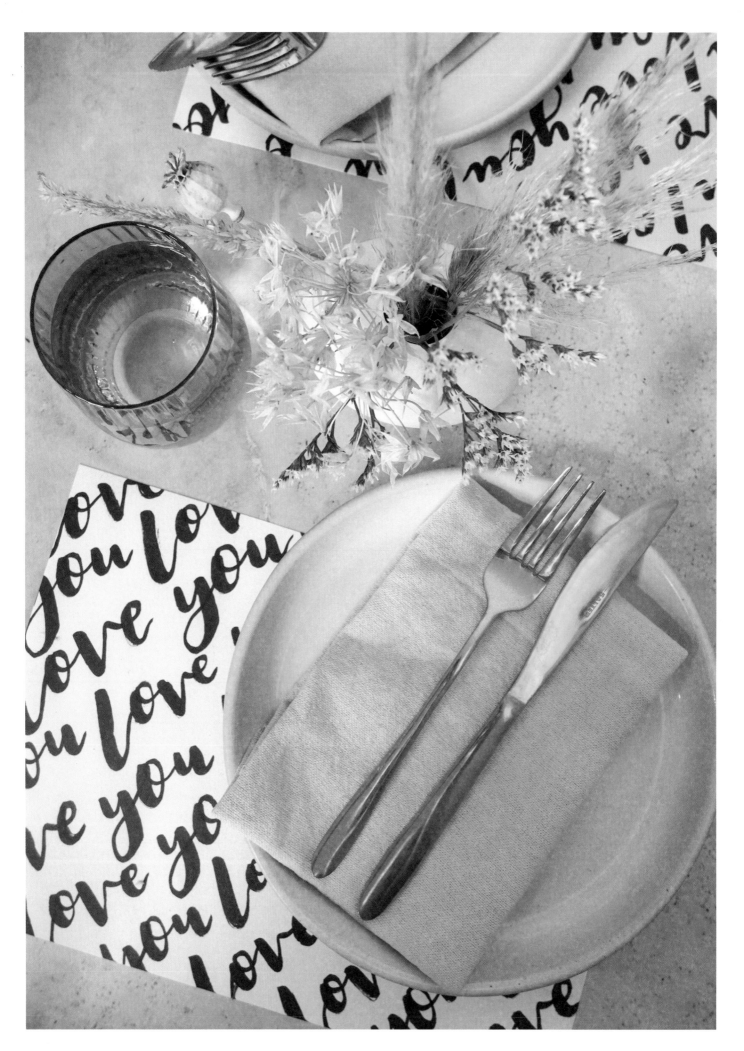

valentine's day placemats

I love styling my dining table with flowers, napkins and pretty ceramics to celebrate special occasions. These pretty placemats were inspired by looking at my practice lettering sheets and will add a really personal touch to your romantic Valentine's Day table setting.

Materials:
- ◼ A4 card
- ◼ Paper
- ◼ Pencil
- ◼ Brush lettering pen

BECKI'S TIPS
◼ If you want all your place mats to look exactly the same then simply scan your design and print it out multiple times.

◼ Place a piece of paper under your card when you are lettering so you don't get marks on your table.

◼ Once the ink is dry, erase any pencil marks with a soft rubber.

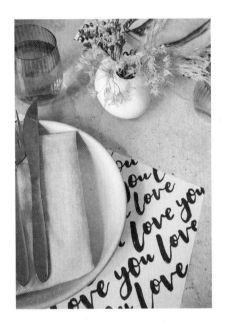

STYLING YOUR TABLE
Start by choosing a theme for your table setting. I usually start with a colour scheme. Here, I've contrasted blush linen napkins with hot pink tumblers and cream artisan tableware. Use your imagination and mix and match. A vase from your bathroom might be perfect with your chosen scheme.

Any length of fabric can be used as a tablecloth if you want to make your setting look a little different. Light fabrics like linens and cotton are best as they hang well.

Add fresh flowers for pops of colour and to create a bit of height on your table. Don't be restricted by what's on sale in your local flower shop. Have a peek in your garden too - long grasses and twigs can make interesting compositions when paired with blooms.

Don't be afraid to mix and match different colours and styles of cutlery and tableware; I think it gives an eclectic and homely feeling to your table setting.

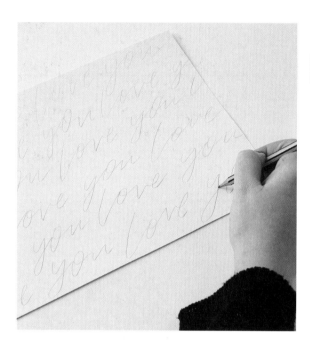

1. Start by thinking of a phrase or word that will work well for your place mat.

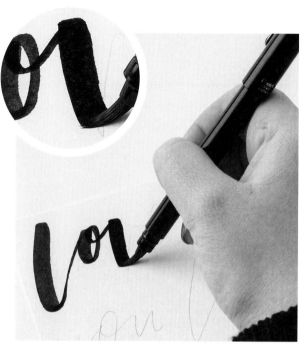

2. You can simply letter the name of your dinner guest or choose something sentimental or funny instead.

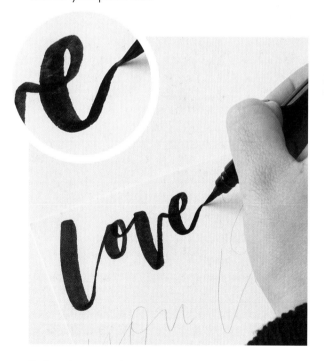

3. Practice your phrase on some scrap paper to see how many lines will fit on an A4 sheet of card.

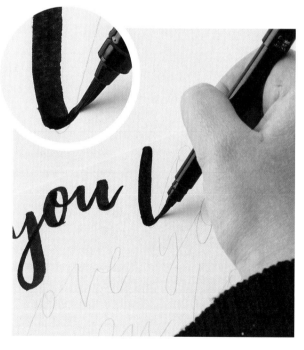

4. If you find it easier to write on lines then use a ruler to make faint lines across the page.

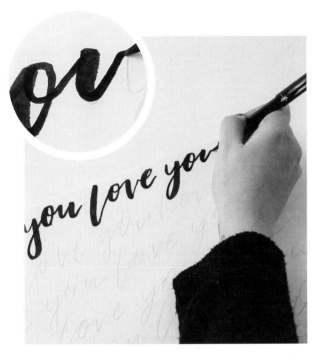

5. Protect your writing surface by putting a piece of paper under your card.

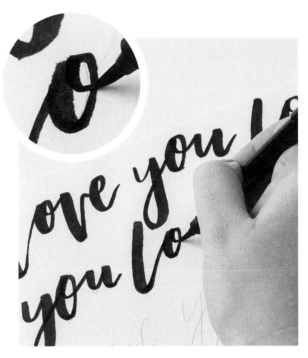

6. Play around with the height of your letters and try to fit them neatly between each other on each line.

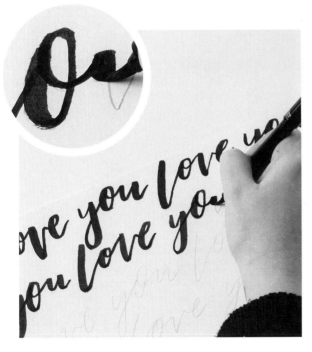

7. Focus on creating a good mix of thick and thin strokes in your letters and less on even letter spacing.

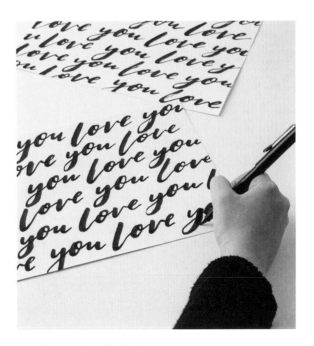

8. When you've finished your mat designs you can laminate them to make them durable.

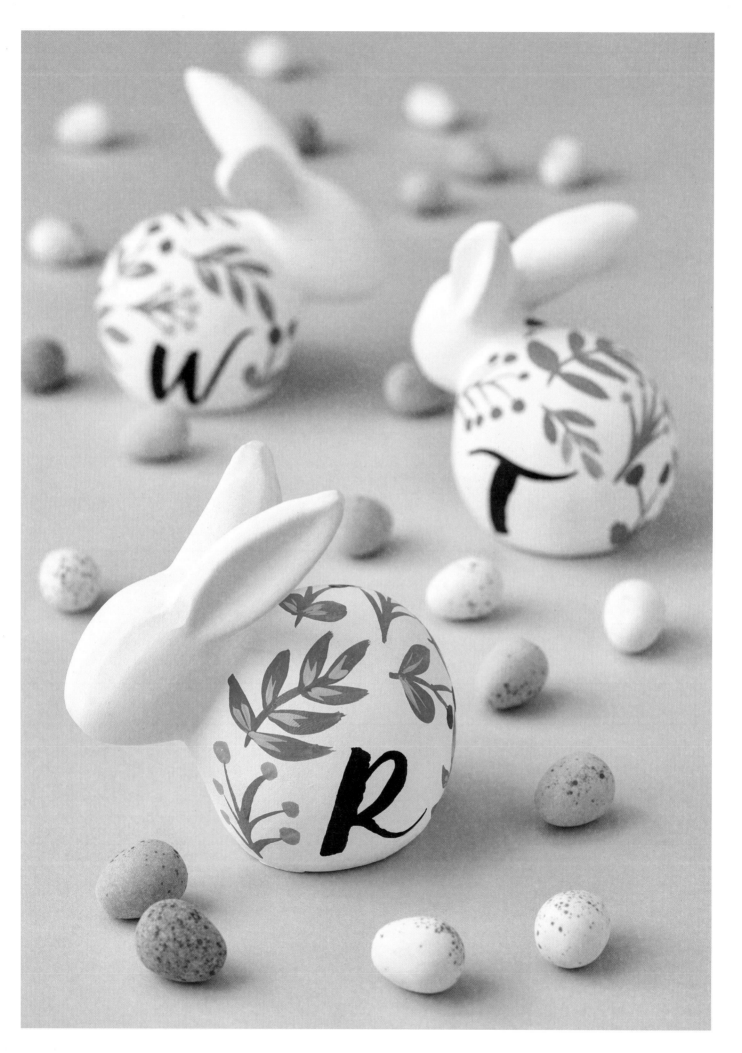

ceramic easter bunnies

Easter is one of my favourite times of year. I love to spend time with friends and family without the pressure of Christmas. For as long as I can remember, my mum has had an Easter tree and decorations she brings out to celebrate the spring. I have always loved to make Easter themed crafts.

Materials:
- Ceramic Easter bunnies
- Pencil
- Brush lettering pen
- Gouache paint in three colours
- Paint brush
- Pot of water

BECKI'S TIPS
- Adding just a little bit of water when mixing the gouache paint will keep the paint consistency thick and the colours opaque.

- If you want to add more detail to your botanical illustrations, leave them to dry before working another colour over the top of them.

- Lovely spring colour combinations are yellow and pink, mint and pink, blue and yellow, green and pink!

- If you make a mistake, leave it to dry and then repaint your bunny white and start again.

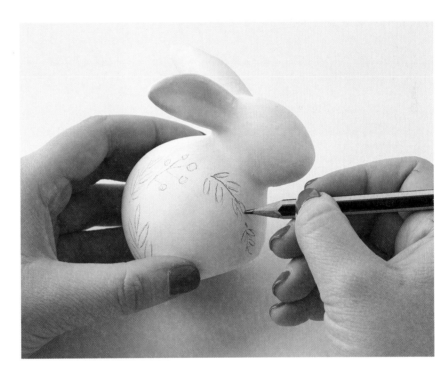

These cheerful Easter bunnies make the perfect little treasures to find on an Easter egg hunt! They also make adorable little place settings for friends coming to an Easter brunch and look lovely as spring themed decorations around the house. In this project, I have used brush lettering with painting. If you are not confident using paint, just stick to brush lettering; they will look just as cute.

1. Firstly make sure your ceramic bunnies are clean and dust free. Use a damp cloth to wipe them clean and wait for them to dry.

2. Use a pencil to sketch out where your decorative shapes will go. Here, I wanted to create an arch around the body of the rabbit with flowers and letter the initials on the bunny's body. I used a mix of three different leaf motifs to cover the bunny.

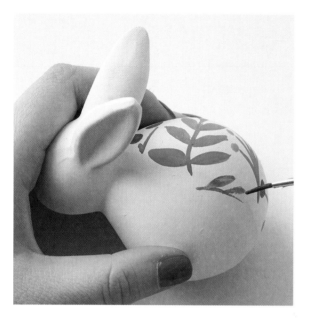

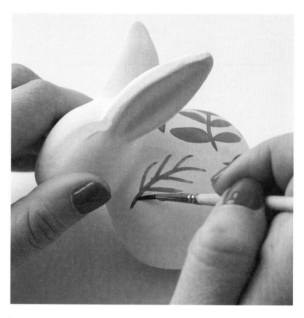

3. Make decorative leaves using simple shapes. Just one paint stroke with teardrop shapes added along its length creates a simple but effective design.

4. If you look at the botanical shapes and break them down into individual strokes and shapes they become a bit less daunting to draw.

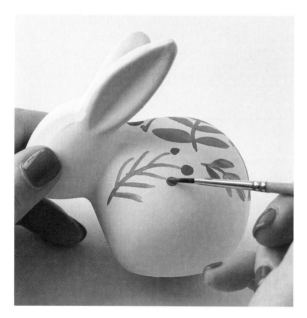

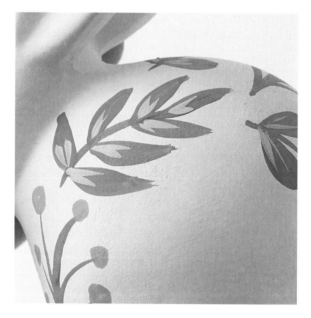

5. The little buds are simply created from soft strokes made with a brush and little coloured dots added in a strong contrasting colour - red in this case.

6. Once the base colour has dried, you can add detail on to each shape with another colour. Experiment with lines, circles and teardrop shapes.

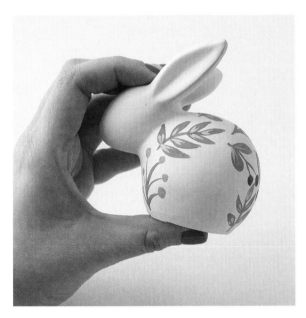

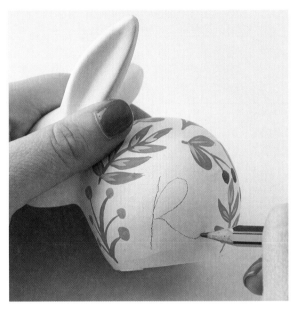

7. Work your motifs across the bunny, being careful not to smudge your work. Leave the paint to dry for a couple of hours before moving on to brush lettering.

8. To get the placement of your initial in the right place on the bunny, pencil it in first. When you are happy with your pencil lines, pick up your brush pen.

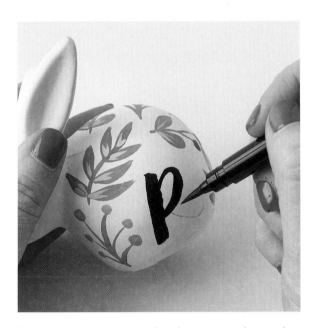

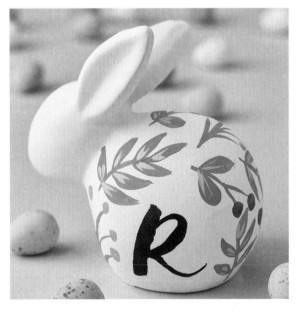

9. Now you can use your brush pen to work over the pencil lines to create your brush lettered initials.

10. Leave your bunny to dry. You could make little Easter cards to match using the same technique.

thank you

you
are invited

celebrate

watercolour notes

Ever since I was a child I've written little notes to people - I even loved writing thank you notes for my birthday and Christmas presents. It still feels special to receive a hand-written letter. These watercolour cards are the ideal way to show your appreciation or keep in touch with an absent friend.

Materials:
- Washi Tape
- A6 cards
- Watercolour paints
- Paint brush
- Water
- Brush lettering pen

BECKI'S TIPS
- Make sure you put a piece of paper underneath your card so that you can work right up to the edges without getting paint on your table or work surface.

- If you want to use more than one colour, you can create an ombré effect by adding different colours to the card and blending them together with water.

- Textured cards work well and give your cards a bit more depth.

- Make sure your washi tape is stuck down securely to prevent any paint seeping on to your plain card .

Make your own watercolour stationery set with this simple masking technique. These would make great postcards, thank you notes or wedding stationery. Imagine watercolour and brush lettered table numbers or menus on your big day! You can really experiment with this technique, creating interesting ombré effects with different combinations of colour. You could also experiment with using watercolour paint rather than a pen to create your brush lettering.

1. Start by sticking a strip of washi tape firmly across the A6 card. You can attach it in any direction you like - diagonally, vertically or horizontally; you are just separating the area you are going to paint on from the area you are lettering on.

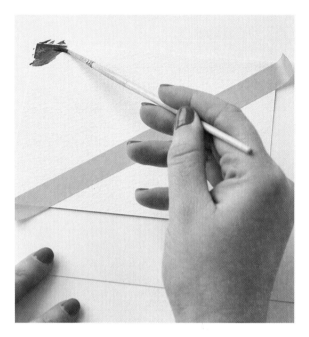

2. Choose your main colour and work the watercolour paint across the card.

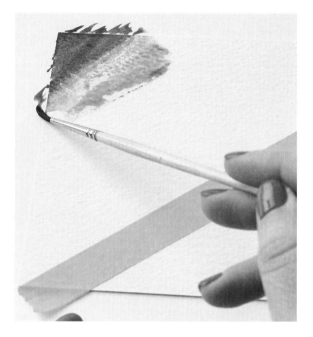

3. Mix the paint with more water if you want a less pigmented and softer look to your design.

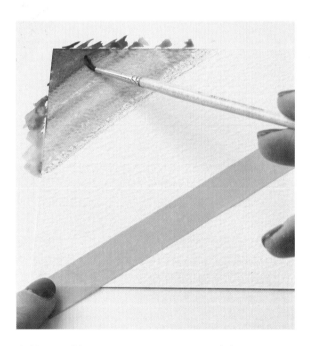

4. Keep adding water to your paint and dragging it down the card towards the washi tape.

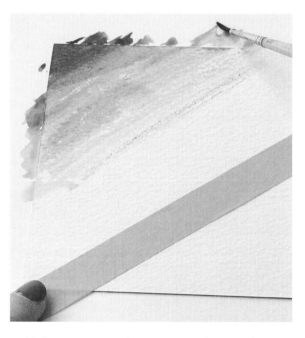

5. Make sure you work your paint right up to the edge of the washi tape.

6. Once the paint is dry, peel back the washi tape to reveal a straight edge of colour across the card.

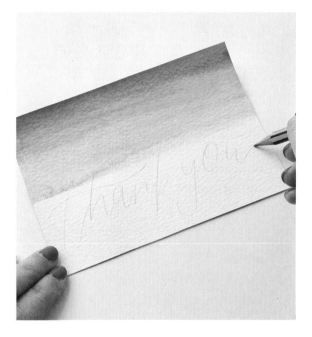

7. Using a pencil, rough out where you want your lettering to be on the white space under the paint.

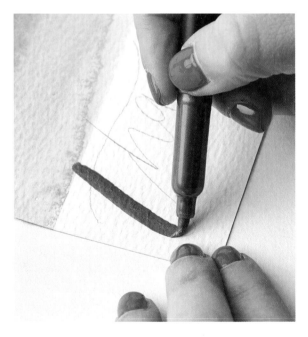

8. Using a metallic pen, brush letter across the card for a beautiful luxury effect.

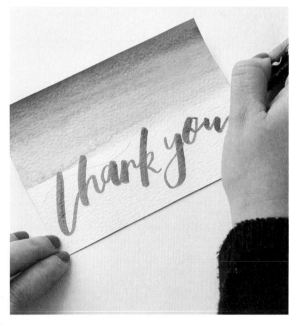

9. If you're feeling confident, you can letter with a brush and watercolour for a more delicate effect.

with love

chapter seven: summer

My summer projects include cake toppers for summer parties, decorative plant pots to display those essential barbecue herbs and personalised place settings made from lemons! Yes! You can brush letter on lemons; they look really pretty and will bring the scent of the Italian Amalfi Coast to your summer dinner party table settings.

Thank you

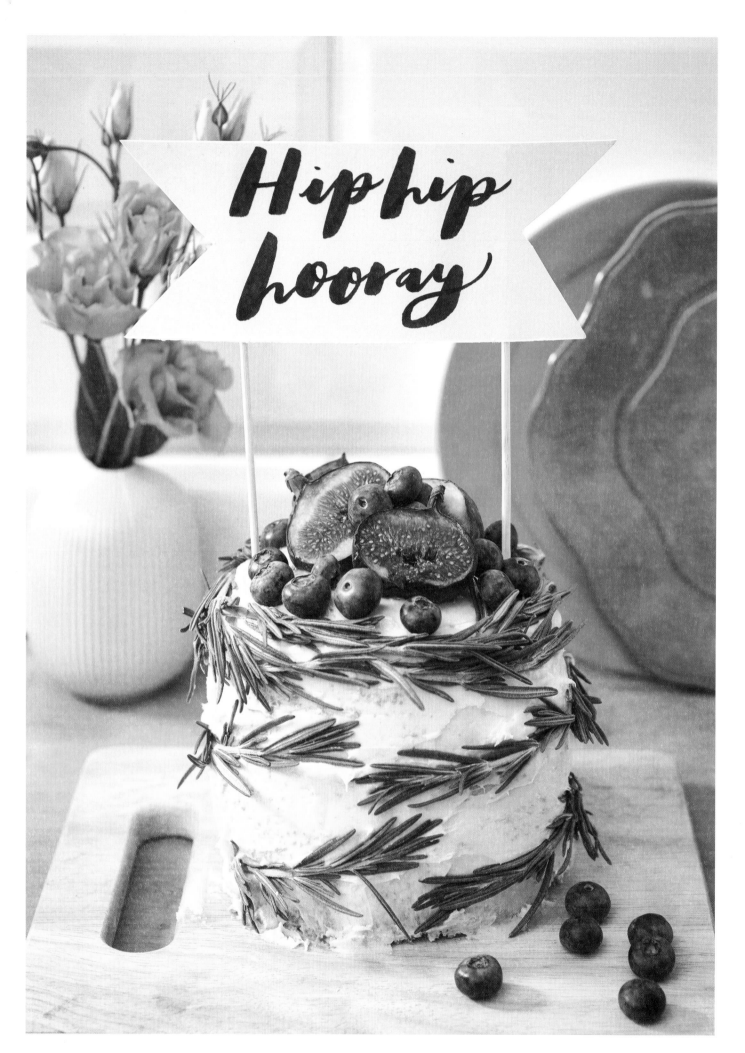

cake topper

I love birthdays! I love the chance to make a fuss over friends and family by making a handmade gift or whipping up a birthday cake and popping round to surprise them. A jazzy cake topper is the best way to make a homemade or shop bought cake extra special. They are simple to make with just a few materials.

Materials:

- Kebab sticks
- Washi tape
- Brush lettering pen
- Scissors
- Pencil
- Ruler
- Card

BECKI'S TIPS

- If you want to create smaller cake toppers for fairy cakes just use cocktail sticks.

- If you're not a star baker or are pushed for time, adding this handmade cake topper will give a personal touch to a shop bought cake.

- If you're into paper cutting this is the perfect project for you. Letter on 200-300gsm card and cut your finished lettering out on a cutting board using a scalpel. Attach to your kebab sticks with washi tape.

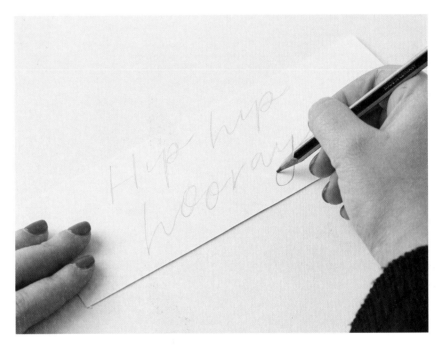

Create an easy cake topper decorated with brush lettering to celebrate a birthday. You'll only need a few materials to make this and it will also be reusable for future birthdays. I'm known as a 'star garnisher' and also love to add fruit and flowers to a pre-bought cake!

1. Work out the width of your cake topper. If you are making fairy cakes then use small pieces of card. If you are making a larger sponge cake then use a piece of card that's around the same diameter as your cake.

2. Cut the card down to a width you are happy with. You can also buy pre-cut card for cake toppers.

3. Use a pencil to sketch out where your lettering will sit. Ideally you want your lettering to be centred in the middle of the banner with equal space around either side of the word. If what you want to letter is a few sentences long, work out if it would look better lettered on two lines.

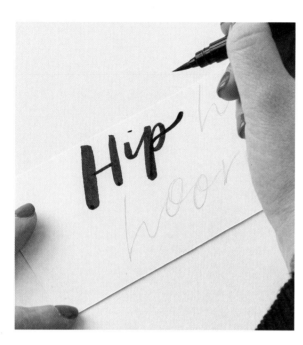

4. Work over your rough pencil lines with a brush lettering pen.

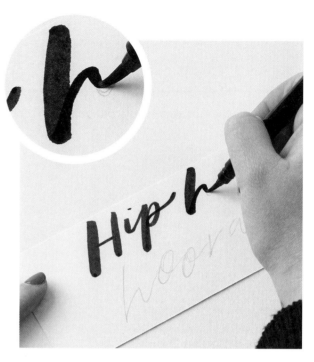

5. Remember to try and add movement and fluidity to your letters by making them different heights.

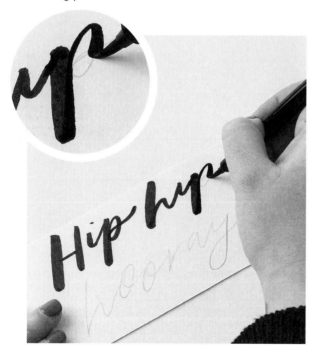

6. Try and keep your flourishes consistent. Here I've given the two 'p's the same length elongated tail.

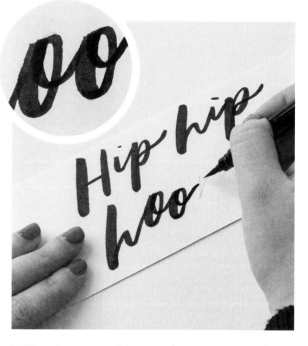

7. If you have two of the same letters next to each other like these 'o's, make them different sizes.

8. Create the flag effect by cutting off the corners of your topper, measuring carefully first to make it even.

9. Place your kebab sticks on the back of the cake topper and use washi tape to secure your lettering.

10. If your topper looks too high on the cake, just cut down the kebab sticks to fit.

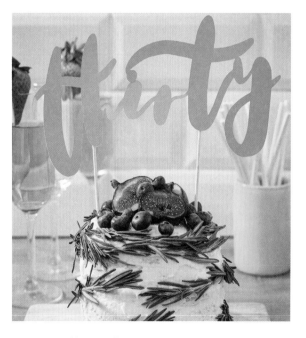

11. For a different effect, cut out the letters with a scalpel and stick them to the kebab sticks.

Pressed flower frames

Flowers play a massive part in my life and pressing them has become one of my favourite things to do. This project combines my love of flora and lettering to create delicate keepsake frames. They look lovely displayed at home and would also be pretty as table names or numbers for a wedding table setting.

Materials:
- Glass gold frames
- Brush lettering pen
- Pressed flowers

Or if you're pressing your own flowers
- Flowers
- Blotting paper
- A book

BECKI'S TIPS
- If you go foraging remember only pick what you need and make sure you're allowed to collect flowers in the area.

- Charity shops often sell interesting frames at bargain prices.

- To speed up the drying process, put your flowers between two sheets of blotting paper and press down on them with an iron set on a low heat.

- Acrylic paint or Posca pens adhere better than watercolour or gouache paint to glass surfaces.

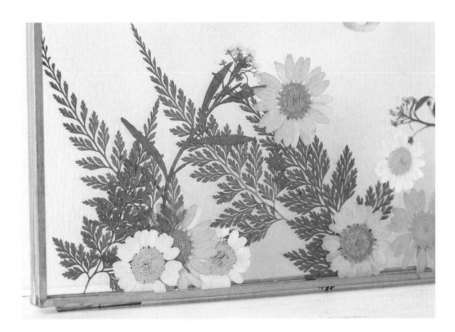

I just love these vintage style gold frames; they are the perfect frame for pressed flowers and gold hand lettering. You can preserve precious memories from summer to display in your home.

1. If you have the time, press your own flowers and foliage to make this project. Flatter flowers press more effectively than round bodied flower heads. I love to use flowers like pansies, violets, lisianthus, long grasses, ferns and, my favourite, cow parsley will press beautifully. Flowers like roses are often too full bodied to press well.

2. To press your flowers you need to place them carefully on a sheet of blotting paper, making sure each flower has enough room around it to flatten. Once arranged, put another sheet of blotting paper on top and place between the pages of a book. Put another couple of heavy books (or a brick) on top of your book and leave for 2-3 weeks for them to dry and flatten fully.

3. For this project I've used a gold pen as I think it compliments the frame well and doesn't look too heavy on the clear glass.

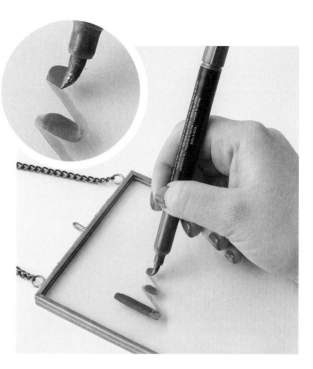

4. You can also use a paint brush and acrylic paint if you can't find a metallic pen in the colour you want to letter in.

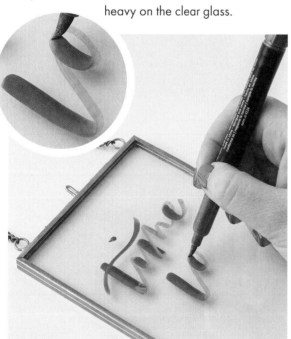

5. Make sure the glass is clean and dry before you start lettering across it.

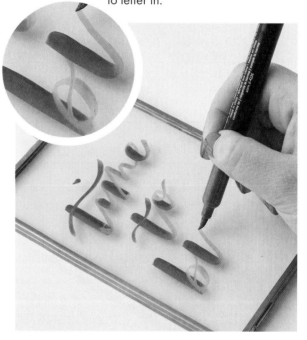

6. If you make a mistake, act quickly to wipe the glass with a wet cloth and start again.

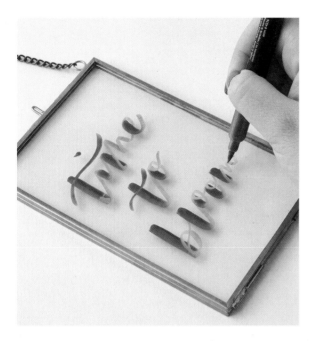

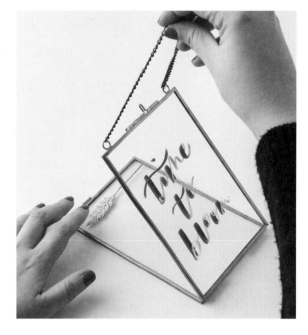

7. When you are happy with the lettering then leave to dry. If you're in a hurry, use a hairdryer to dry it.

8. If your frame clips tightly together, you can place the flowers inside with no adhesive.

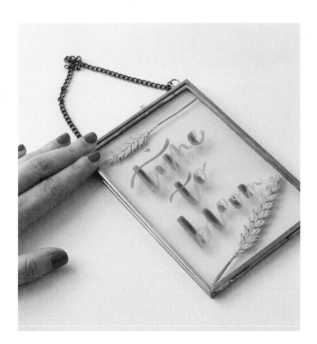

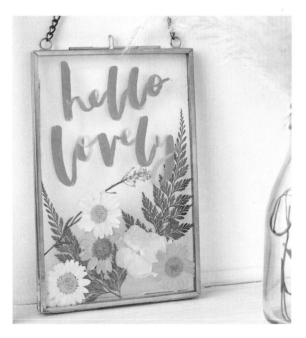

9. If your flowers slip to the bottom of the frame then use a tiny bit of PVA glue to attach them to the glass.

10. The PVA glue will dry clear so don't worry about any glue marks on the glass.

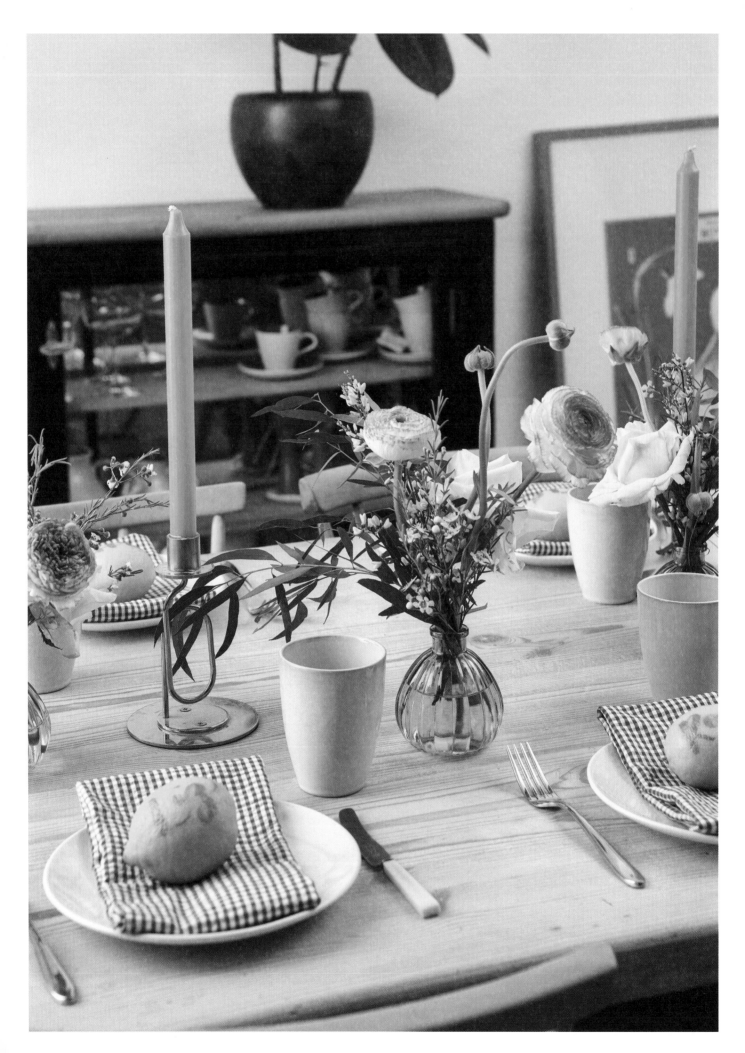

a summer's table setting

I try to find joy in the small things in life like inviting my friends over for dinner and decorating the table to reflect the season. For a recent summer gathering I wanted to create something that reminded me of Italy. These lemon place names paired with summer blooms and gingham napkins do just that!

Materials
- Lemons
- Brush lettering pen

BECKI'S TIPS
- These would look great as place names for a summer wedding or party.

- I've found that metallic pens work better on waxy surfaces like lemons. My favourite is the Kelly Creates metallic jewel brush pen in gold.

- For a more kitsch look you could spray paint your lemons before you start your brush lettering.

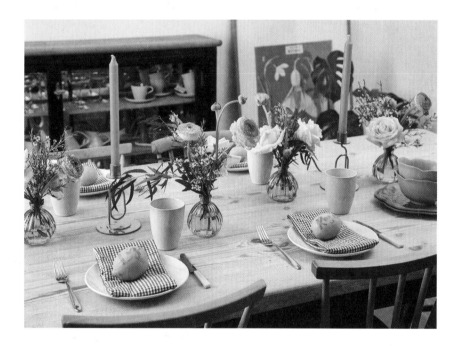

STYLING YOUR TABLE
1. I love gingham! The combination of lemons and blue and white checks immediately makes me think of summer. To make these napkins, I used some old fabric in my craft stash, cut it down to the right size and hemmed the edges.

2. Rather than a big bouquet in the centre of the table, fill lots of smaller vases with flowers and spread them down the centre of the table for a pretty informal look.

3. Flowers that make their own interesting shapes work best in mini vase displays.

4. Candles will set the mood and also add visual interest (and a lovely smell) to your table.

5. Other citrus fruits would also work well for this project. You would create a completely different look and feel to the table if you used limes and lots of greenery in vases, or grapefruit and wild hedgerow plants paired together, for example.

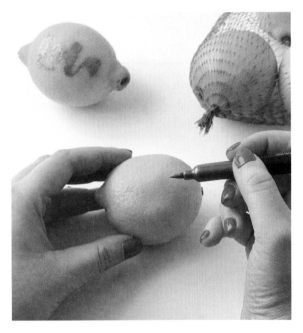

1. Wash your lemons and then dry them. Unwaxed lemons work best for this project.

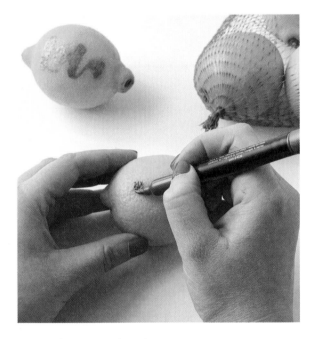

2. Pencil won't work on lemons so practice writing your names on paper until you feel confident.

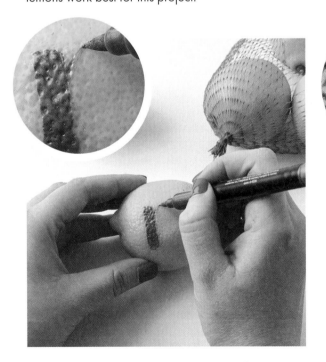

3. Brush letter your name on the lemon, taking your time over the curved surfaces.

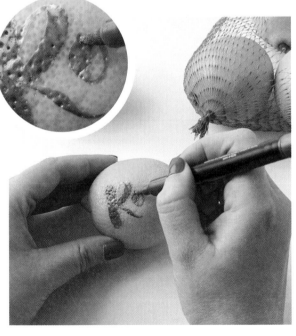

4. Paint pens work well on curved surfaces as you , need a flexible tip to create your thick and thin lines.

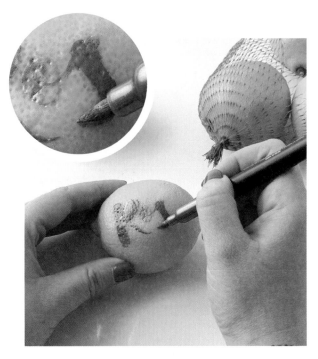

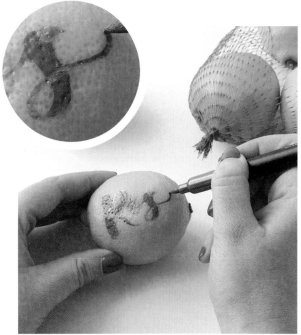

5. Because your surface can be quite waxy, you may need to work over some parts of the lettering twice.

6. Remember to keep focusing on creating a mix of thin and thick lines throughout your lettering.

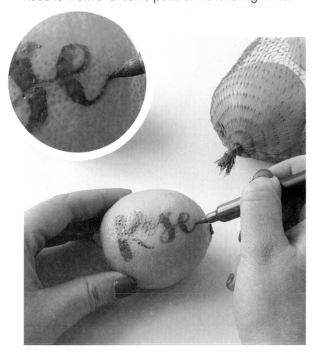

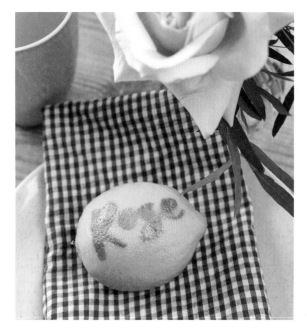

7. Leave the lemons to dry, making sure the lettering is face up so it doesn't smudge.

8. Once dry, you can arrange the lemons on your napkins ready for your guests to arrive.

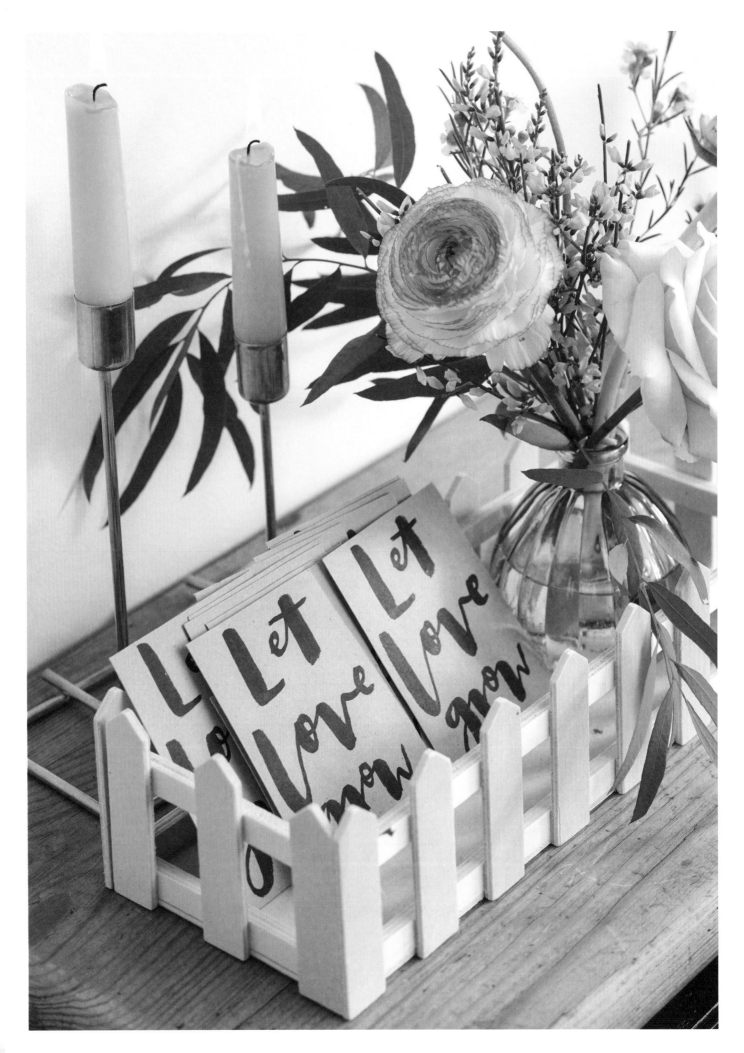

wedding favours

If you're planning a wedding this year, then these brush lettered favours are a great way to add personalisation and a handmade touch to your big day. Invite your bridesmaids over for a crafty evening and get a production line on the go for seed packing and lettering! Your guests will adore these pretty gifts.

Materials
- Mini envelopes
- Flower seeds
- Brush lettering pen
- Pencil

BECKI'S TIPS

- Choose the seeds of the flowers in your wedding bouquet. That way, when your seeds grow in their new home they will be a permanent reminder of your special day.

- Keep your seeds in a cool dry place to ensure they are still viable. You don't want them to get damp or too warm.

- Dried flower petals are a great alternative to traditional confetti and would be lovely in these envelopes too.

- Make a larger version of your phrase to display above the envelopes so everyone remembers to pick up their gift.

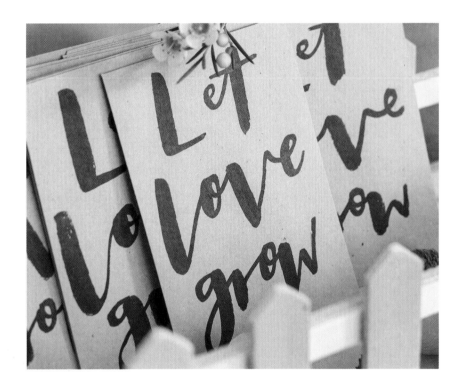

Make your big day extra special by creating your own brush lettered wedding favours. This project is simple and easy to make but oh-so-effective. These pretty little envelopes will look great displayed at your venue.

1. 'Let love grow' works brilliantly as a phrase for these envelopes because the words fit so well one underneath another. I also think it's a lovely phrase for wedding favour. If you want to try a different phrase just mark out the size of your envelopes on a piece a paper and practice to check it fits. Remember to consider the composition of your phrase and to work out if it looks best over one or two lines. Also think about whether you want to add some hierarchy and make some words larger than others.

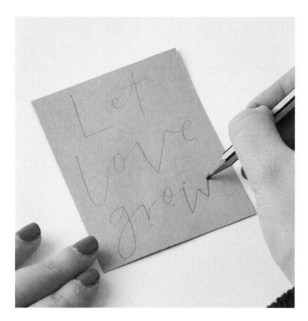

2. If you are making a few envelopes, you will soon get confident enough to just need to pencil in the placement of the words.

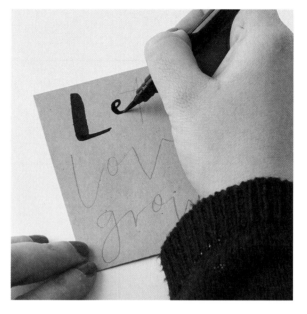

3. Begin lettering onto the envelopes, pressing down on your downward strokes and lightening the pressure on your upward strokes.

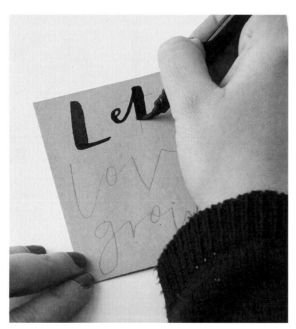

4. You can buy small money envelopes in many stationery shops and online. They are cheap, sold in bulk and the perfect size for this project.

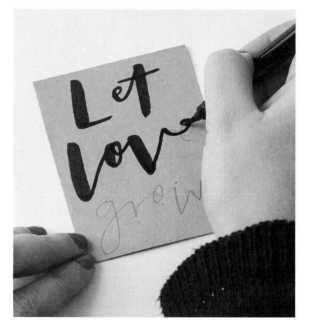

5. Leave the ink to dry for a few minutes. You might want to create a drying rack for this project if you have a few to make.

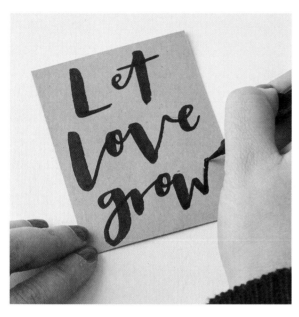

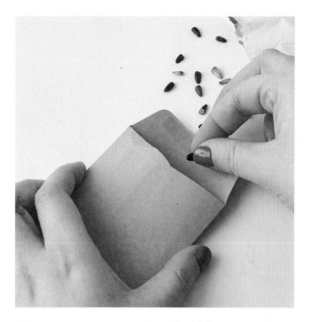

6. When you've lettered your last envelope, leave them all overnight to make sure they are perfectly dry.

7. Separate out your seeds and add them to each envelope closing it firmly once they are full.

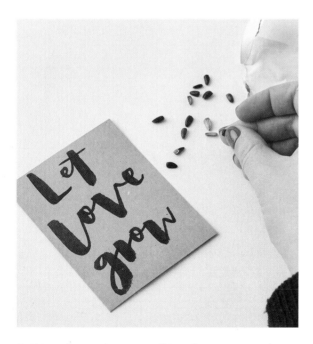

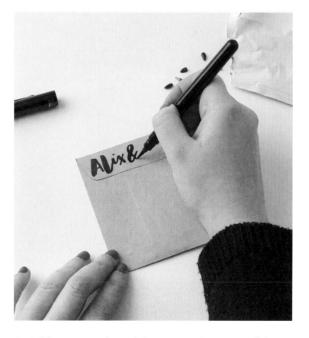

8. Wrap the seeds in a small bit of tissue paper if you don't want them loose in the envelope,

9. Add a personal touch by writing the name of the happy couple on the back of the envelope.

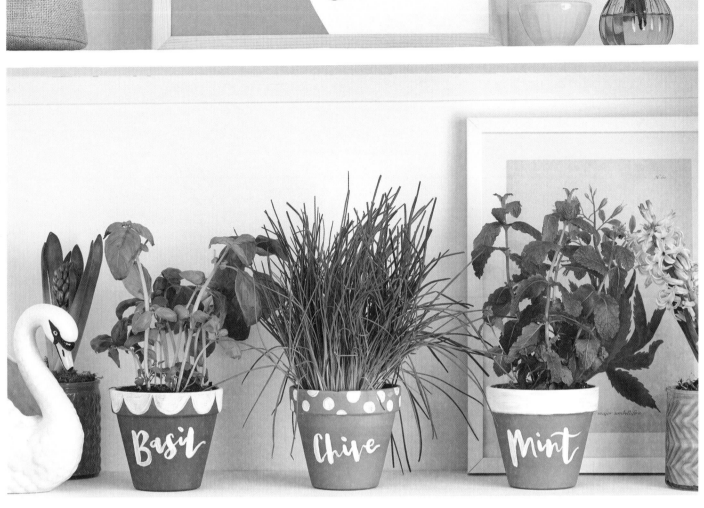

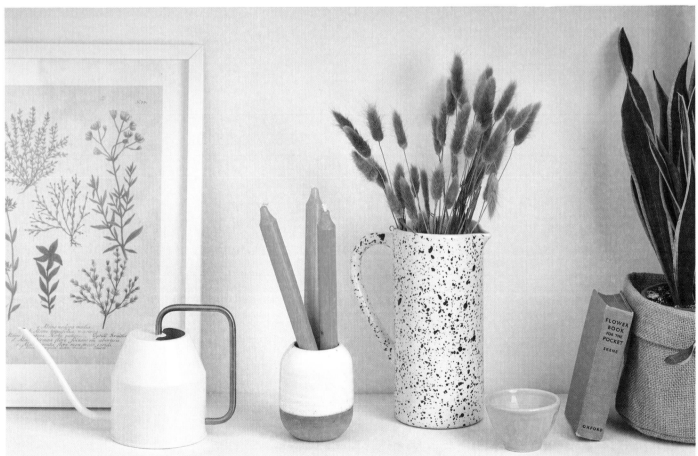

terracotta herb pots

Creating a set of herb pots decorated with fun patterns and lettering is a gorgeous way to display your brush lettering. You can match the colour of the lettering to your kitchen scheme for a pretty effect. Filled with herbs, these little pots make lovely thoughtful housewarming gifts.

Materials:
- Terracotta pots
- White acrylic paint
- Paint brush
- Water
- Pencil

BECKI'S TIPS
- If you want to create a few pots then use a mixture of patterns to create a collective look.

- Leave at least 24 hours for your paint to dry.

- If you don't feel confident using paint, an ink base brush lettering pen works well on terracotta too.

- To ensure your lines are straight, use washi tape to mask off areas of the terracotta pot.

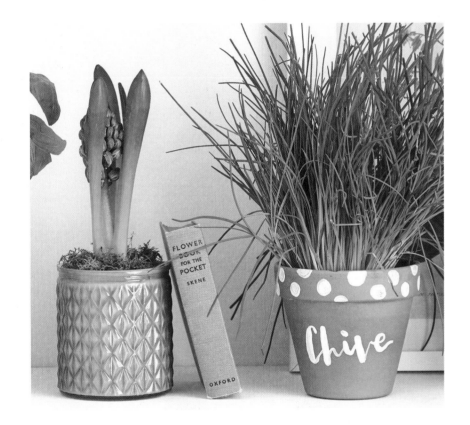

This simple project is a fun way to make pretty new pots for plants, flowers and herbs in your house or garden. Creating graphic patterns to compliment your brush lettering gives them a professional designer look. Don't confine yourself to pots; this technique works well on any terracotta surface. Have a good look around your local garden centre for inspiration. It is important to line the inside of your pots with some old plastic bags, yoghurt pots or sponges before filling them with soil, to make sure your design is well-protected when you water your plants.

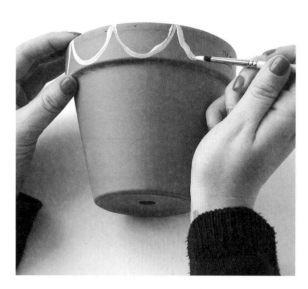

1. Start by creating a simple graphic pattern around the rim of the pot.

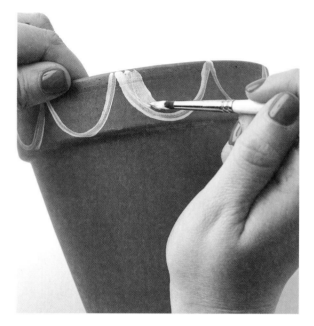

2. Mark out your pattern first and then fill in the shapes with the paint. Acrylic paint works best.

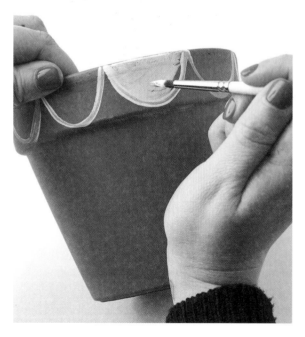

3. Scallop shapes, spots and stripes are easy shapes to paint. Wobbly lines add to the rustic effect!

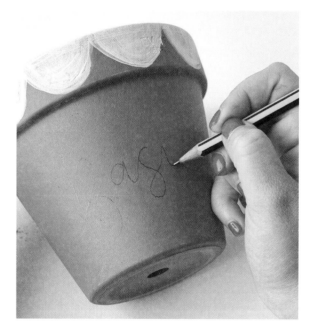

4. When you are happy with your pattern, use a pencil to sketch the name of the herb on the pot.

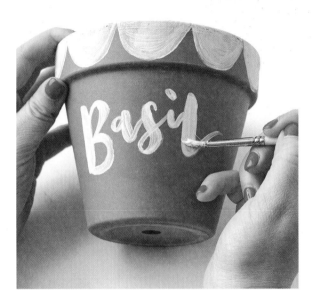

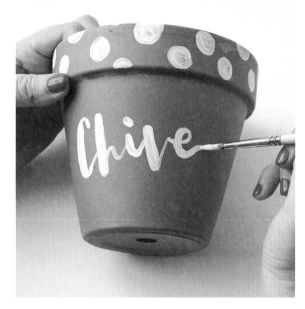

5. Next, use a fine brush and paint to brush letter over the pencil lines.

6. When lettering with a paint brush, don't forget you are aiming to make thick and thin strokes.

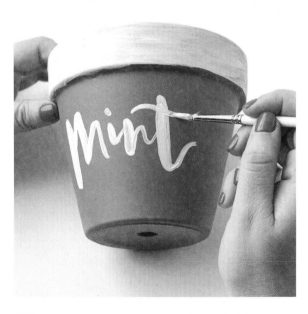

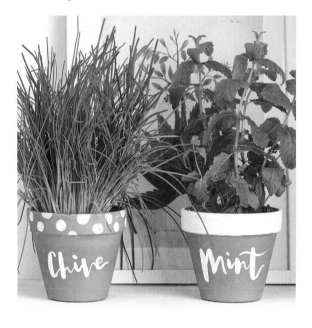

7. If you are struggling to make your strokes in one movement just go back and fill them in later.

8. Pop a liner in each pot, fill with some good soil and plant your herbs in their new home!

chapter eight: autumn

Nothing beats the gorgeous hues of autumn. I find the colours and textures really inspiring and there are lots of reasons to get making during this season. Try painting and lettering pumpkins (don't forget to make soup afterwards!), hand letter and decorate your own enamel cups for firework night or make some brush lettered treats for cosy nights at home.

brush lettered pumpkins

They're creepy and they're kooky... up your Halloween game this year with these no carve pumpkins. A minimalistic take on the classic idea of decorating pumpkins, they will make the perfect touch to add to your spooktacular display. Once Halloween is over you can still use insides to make a delicious pumpkin pie.

Materials:

- Pumpkin
- White acrylic paint
- Paint brush
- Brush lettering pen

BECKI'S TIPS

- Display your pumpkins in groups of three. Odd numbers always work better than even numbers in a display.

- Look out for some bright green and orange flowers to display alongside your pumpkins.

- If you are feeling confident why not try and carve out your lettering? I'd advise creating a simple one word design.

- Patterns and motifs will also look really effective on your pumpkins. Try simple shapes like spiders webs, stars, polka dots and stripes.

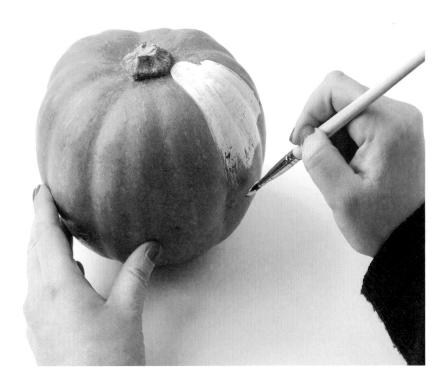

1. You'll see beautiful natural white pumpkins all over Instagram in October but they are actually quite hard to find. Cheat and paint any pumpkin, squash or gourd white and you can hand letter on them too. Natural pumpkins are actually too waxy to letter on anyway so this is a great way to get a brilliant Instaworthy pumpkin and show off your lettering skills.

2. Start by painting your vegetable with a thick coat of acrylic paint, I use a drop of water to make it easier to work over the bumpy surface. Put newspaper underneath your pumpkin and wear an apron, as acrylic is harder to remove than other paints.

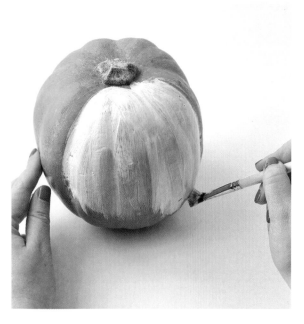

3. I chose white for this project, but any colour works well. Pastel colours or brights look great.

4. Leave the pumpkin to dry for a couple of days. If you are in a hurry, you can use a hairdryer.

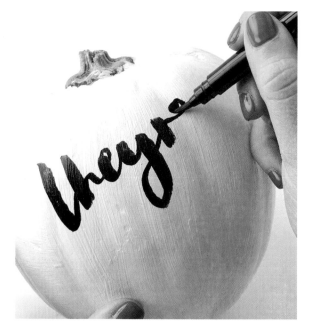

5. Put your pumpkins on a flat surface and begin brush lettering around them.

6. Longer words and phrases work particularly well on the large surface area of a pumpkin.

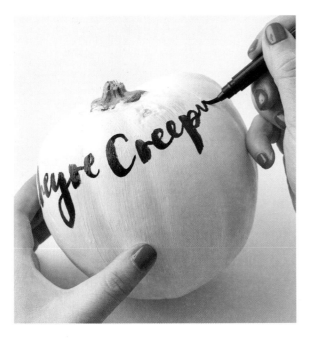

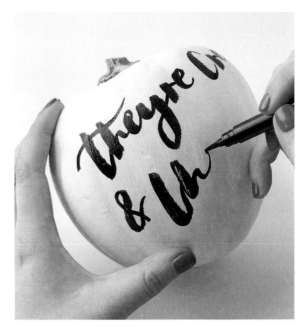

7. If you make a mistake, just cover it up with more paint and wait until it has dried to continue.

8. Working on a curved surface is harder than on paper, so you may need to redo some letters.

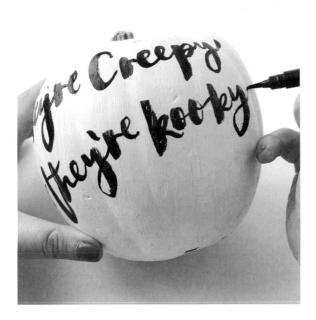

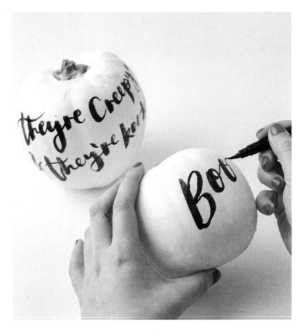

9. Using a paint brush is a quick and easy way to fill in any gaps in your lettering.

10. Once your pumpkins are dry, they are ready to display around the house. Happy Halloween!

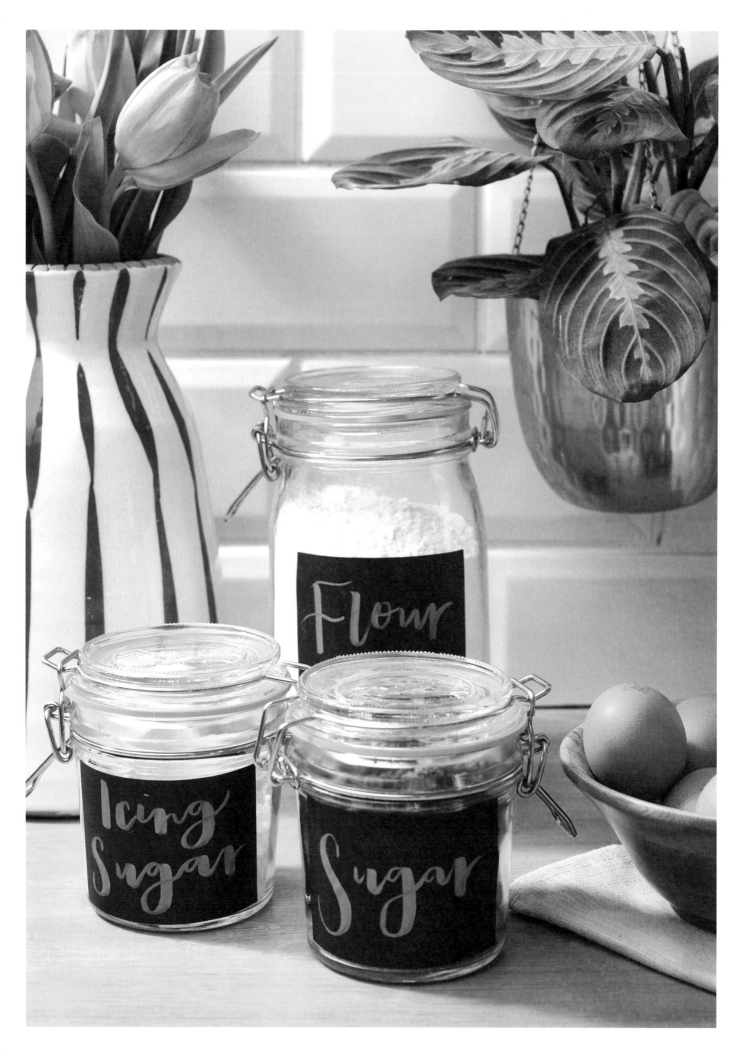

chalkboard labels

Traditional glass Kilner jars are a great environmentally-friendly way to store your dried food. I love their classic design and like to display them on my kitchen shelves. Making brush lettered chalkboard labels for your jars looks stylish and means you'll never get your self-raising and plain flour mixed up again!

Materials:
- Chalkboard labels
- Brush lettering pen

BECKI'S TIPS
- You can buy chalk pens for a really authentic look. However, I do find they don't often have a flexible enough tip for brush lettering. Just be aware you might need to really exaggerate your lettering to get the right effect.

- If you want to work on a larger surface, create lines with washi tape to sit your letters on.

- If you make a mistake, simply wipe your label clean and start again

- Why not try lettering straight onto the glass? Paint marker pens like the Posca range will work well on shiny surfaces.

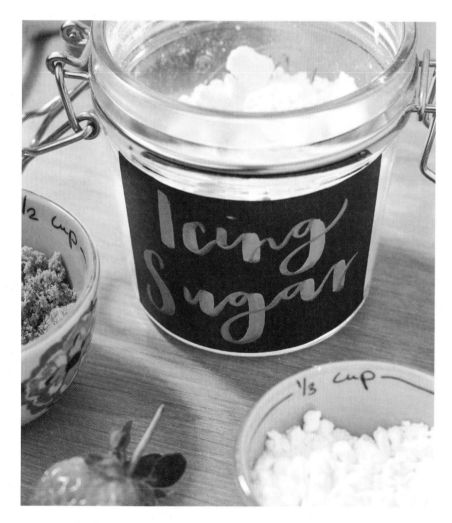

Give your kitchen a new lease of life with these brush lettered gold labels for Kilner jars, pots or storage boxes. The chalkboard surface is washable so you can change the labels really easily. Work in colours that best suit your kitchen - think pastels, metallics or classic monochrome.

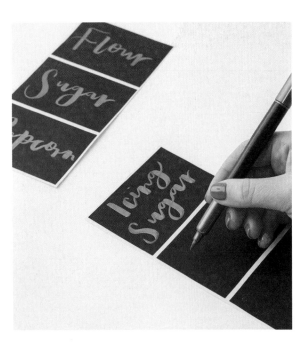

1. Start by wiping your chalkboard labels to remove any grease or dust.

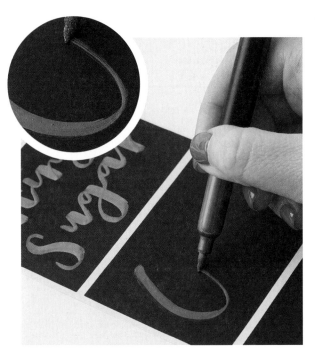

2. You can use a pencil on chalkboard labels if you want to trace out your letters.

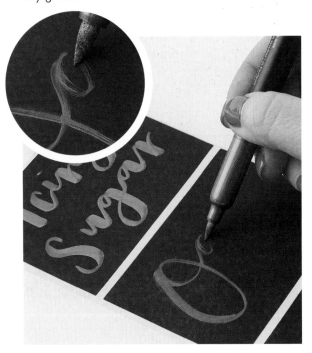

3. Using a light coloured pen (white, gold and silver work well) letter the ingredient names on the labels.

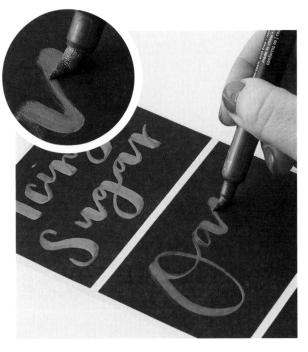

4. The wipeable surface is a bit shiny and will take time to fully absorb the lettering ink.

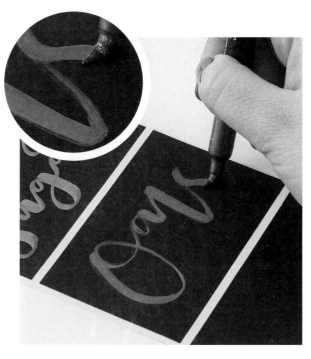

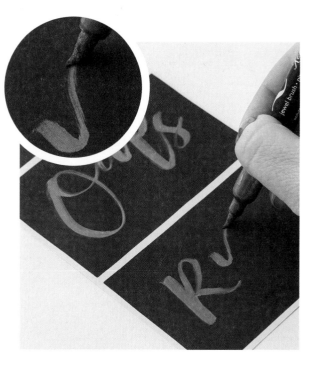

5. If you are using a paint or chalk pen, work back over your downward lines to thicken up the strokes.

6. Your letters don't need to sit on the same line; a difference in height makes your lettering more stylistic.

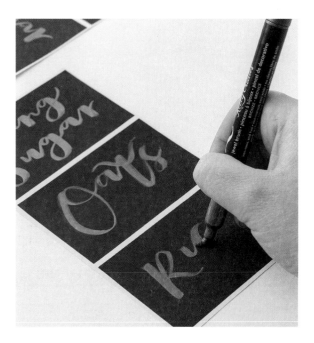

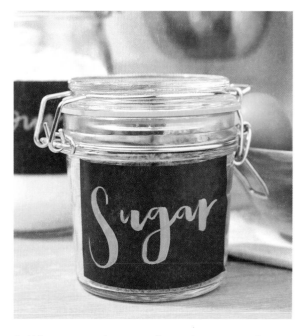

7. Leave your labels to dry. You can change the lettering by simply wiping it off with a wet cloth.

8. When you are happy with your lettering, stick your labels neatly to the jars and put them on display.

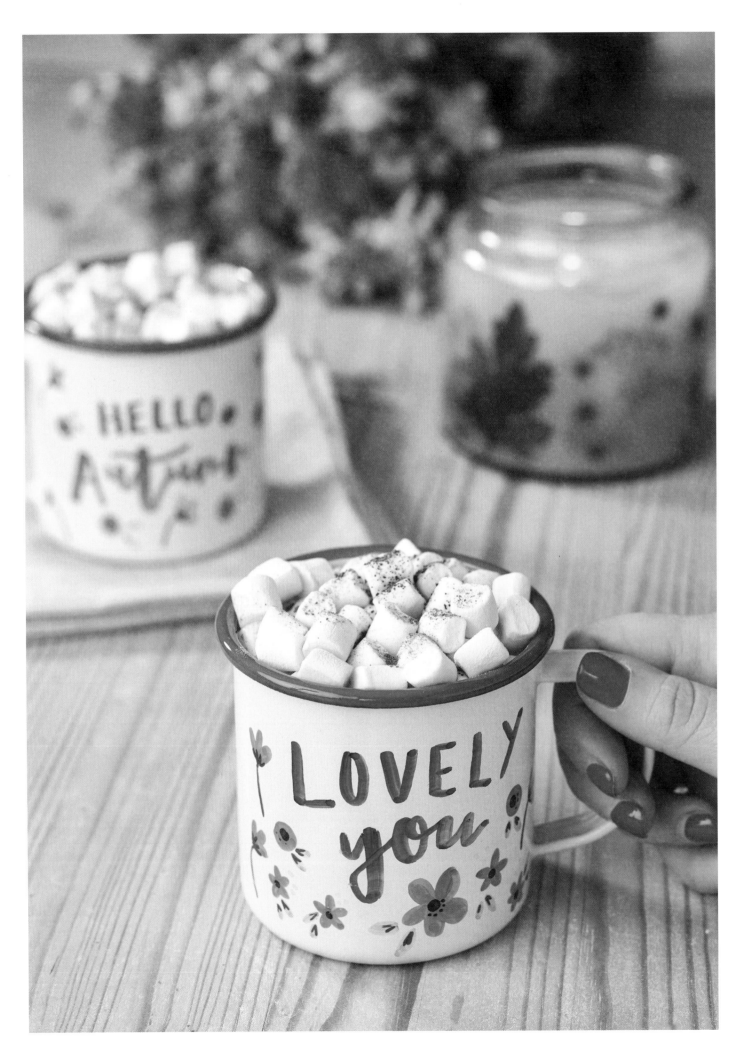

enamel cups

If you're a fellow happy camper like me, you'll probably own some enamel cups like these ones. Add simple floral patterns and brush lettering to your enamelware and pretty-up your camping trip. Once the camping season is over, they are perfect for hot chocolate and marshmallows in front of the fire at home.

Materials:
- ◼ Enamel mug
- ◼ Permanent markers (the Docraft dual tip is good)
- ◼ Oven

BECKI'S TIPS
- ◼ If you think florals might be too difficult, spots, stripes, dashes or abstract shapes work just as well.

- ◼ Baking the mugs will set the design but they won't be dishwasher safe. You'll have to hand wash them.

- ◼ You can also use this technique on ceramic surfaces as well as on enamelware.

- ◼ Stick to a simple colour palette. I chose blues and reds to match the rim of this cup but you can use any colours you like!

- ◼ Permanent markers are not food safe so be careful using them on any surface that will come in direct contact with food.

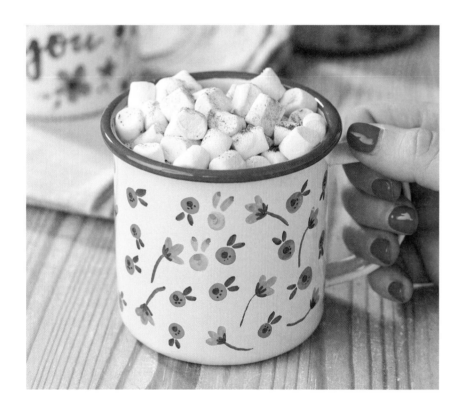

1. First decide on the phrase for your enamel cups. I chose 'hello autumn', because I love to welcome a new season, and 'lovely you' because I think it's a lovely phrase to write on a mug I want to give as a special gift.
2. This is a bit of a go for it project! You'll have to think about how much space your phrase will take first. It's best to practice it on a piece of paper before you move on to the mug. If you don't want to free-style your design, cut a piece of paper to the same size as the mug to work out the exact space you have to work with and practice on this.

If you go wrong at any stage, you can easily wipe away your mistake without ruining any of the rest of your design. It only sets when baked.

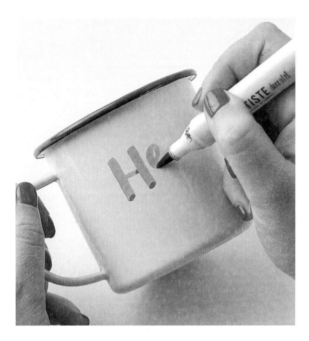

3. Make sure you choose a strong dark colour for your lettering and start on the front of the cup.

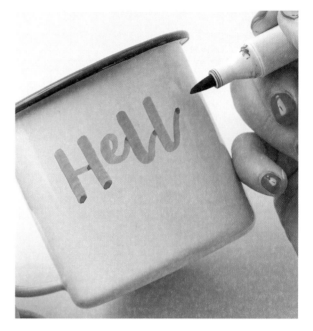

4. I like to use a mix of lettering styles to create a quirky rustic effect.

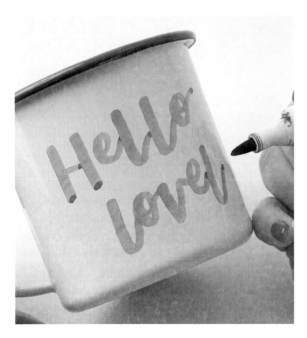

5. When you've lettered your phrase across the mug, its time to add some decorative floral patterns.

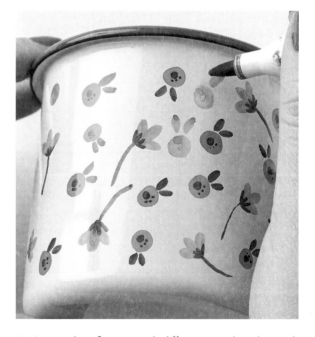

6. Create ditsy flowers with different sized circles and leaves with simple teardrop shapes.

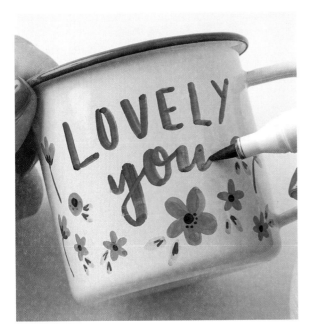

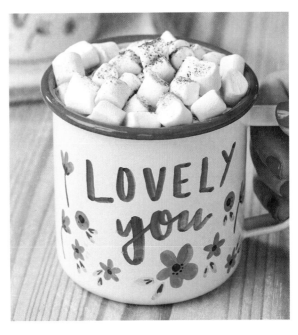

7. Mix the sizes and colours of your flowers before adding the stems and leaves. Tidy up the letters.

8. You don't have to cover the whole cup with your pattern; just work around your lettering to frame it.

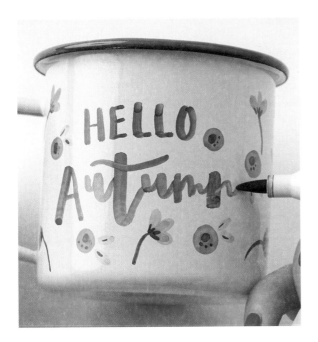

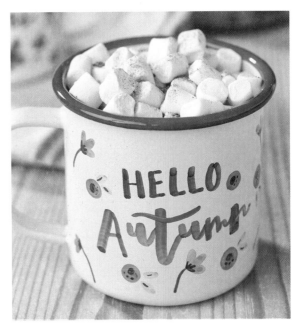

9. You can leave your cup to dry and then draw further designs over the top to create a 3D effect.

10. Put the mugs in the oven on 350°F or 180°C for 30 minutes to set the design. Leave to cool.

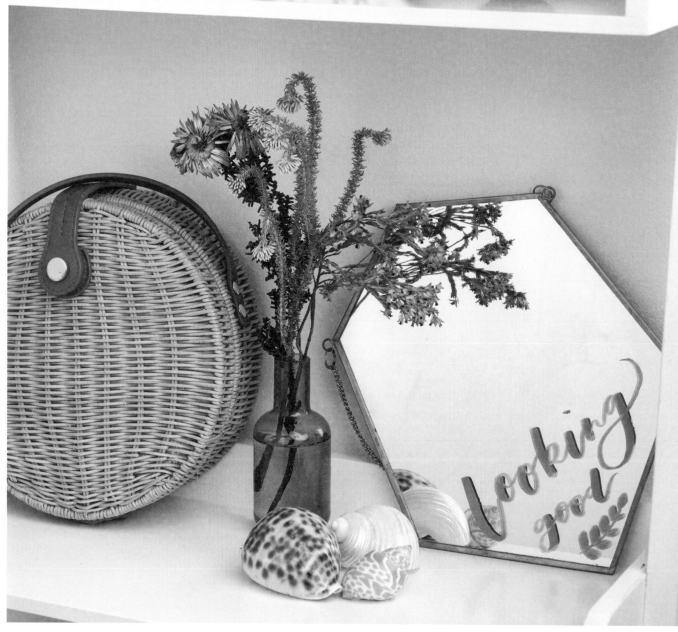

brush lettered mirrors

During the autumn, I tend to spend more and more time nesting at home. I love to think of ways to upcycle and repurpose items I already own to give them a new lease of life. Brush lettering cheerful messages on mirrors is one of my favourite upcycling projects. These delicate mirrors are also great for styling weddings.

Materials:
■ Mirrors

■ Brush lettering pen

BECKI'S TIPS
■ If you need a straight line to help you work out your spacing, use washi tape as a temporary ruler across the mirror. Once you've finished lettering, you can peel off.

■ This project is a great way to make older mirrors look modern. Charity shops are a good place to find old mirrors to upcycle.

■ Posca paint marker pens work well on mirrors and glass surfaces. Posca pens don't have a brush tip but you can create a brush lettering look by returning to each downward stroke and thickening it up.

■ If you find you have some awkward spaces in your lettering, you can fill the gaps with flourishes.

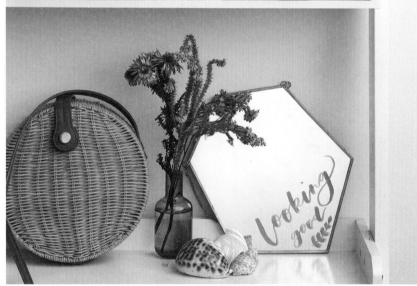

Upcycling old mirrors with uplifting motivational words and phrases will make you smile every time you put your make-up on. You can match your lettering colour to your mirror frames, as I've done in this project, or clash bright coloured lettering with painted mirror frames. It's great fun to make something uniquely bespoke for your interiors style.

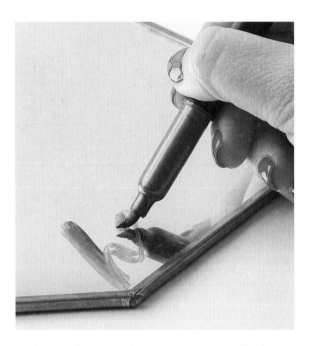

1. First, wipe your mirrors with a soft cloth to make sure they are dust free and clean.

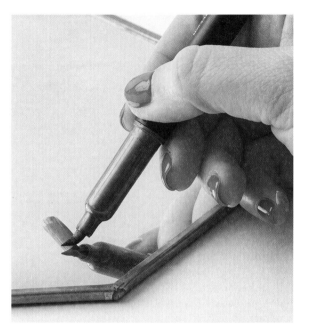

2. Keep your pattern to the sides of your mirror if you still want to use it as a looking glass.

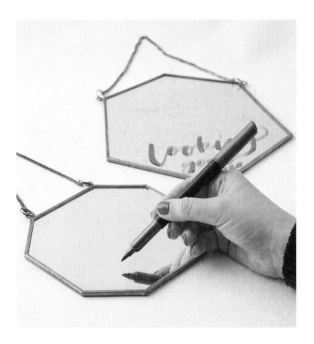

3. If you make a mistake, you can wipe it off with a wet cloth before starting again.

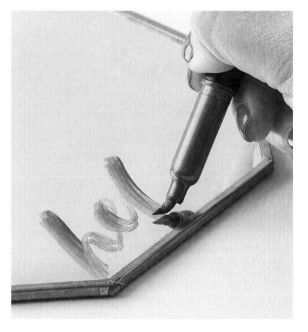

4. You may find your pen marks go slightly more translucent on the shiny mirrored surface.

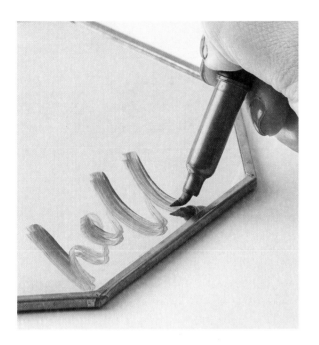

5. Work over your phrase again once it has dried a little to make sure it is completely opaque.

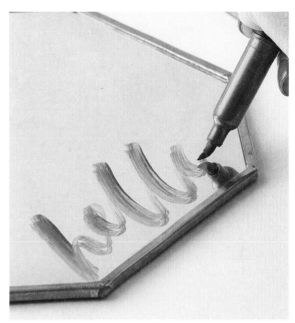

6. By giving your letters tails you can take a break between each letter and take your time.

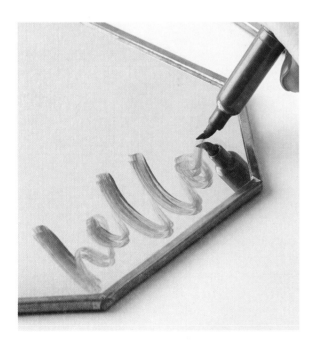

7. The lettering is harder to remove when it has dried, but a light brush with a scouring brush will remove it.

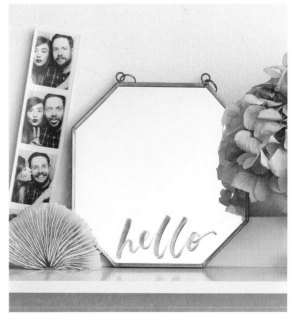

8. If you want to make sure your lettering stays permanent, spray your mirror with hairspray.

abstract envelopes

A prettily decorated envelope is often the first thing someone will see of your brush lettering skills. These abstract painterly envelopes are a great way to show off your style and lettering skills. They are also a lovely way to experiment with painting and mixing colours and shapes.

Materials:
- Watercolour paints
- Wide brush
- Water
- Envelopes
- Brush lettering pen

BECKI'S TIPS
- Put paper underneath your envelopes so any excess paint doesn't ruin your work surface.

- There is no right or wrong way to create these abstract shapes so have fun with this project. Everyone has their own personal style when it comes to mixing colours and shapes together. Just enjoy experimenting!

- You can use your brush lettering pen to doodle shapes across your envelope. Don't forget the back of your envelope.

- Before you start, get some paper out enjoy trying out different colour combinations and shapes.

Create your own envelopes with painterly brush stroke paint effects paired with bold brush lettering.
1. Begin by choosing your colour palette. I chose a muted pallet of oranges, pinks, browns and terracotta for these envelopes.
2. Add a bit of water and mix the paint so it spreads smoothly when you start make brush strokes.

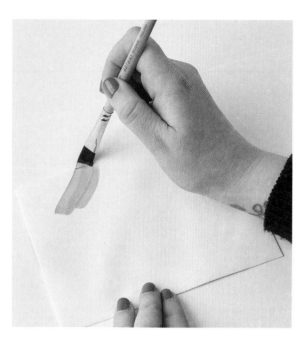

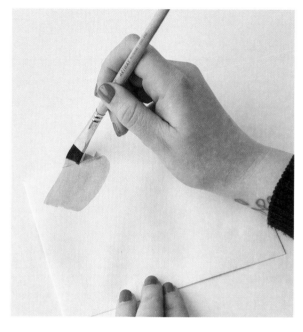

3. Start by brushing paint strokes across the corners of the envelope using a wide paint brush.

4. Apply more pressure to make thicker painterly strokes and less pressure for thinner strokes.

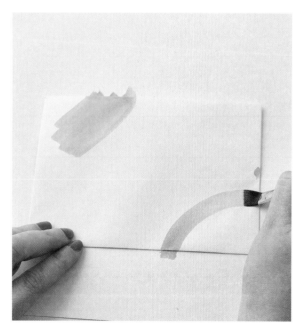

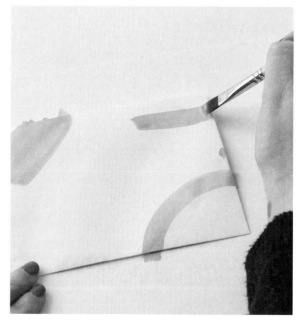

5. Mix brush strokes, shaded blocks and circular shapes over the four corners of your envelope.

6. You'll start to find your natural style. I find I always tend towards circles, triangles and spots.

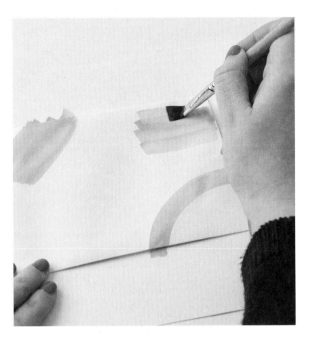

7. Keep adding water to the paint as you work across the envelope to create a watercolour effect.

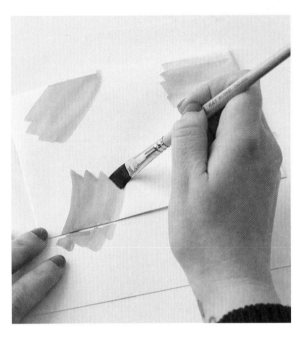

8. Add more pigment and less water to your brush for a deeper colour and texture.

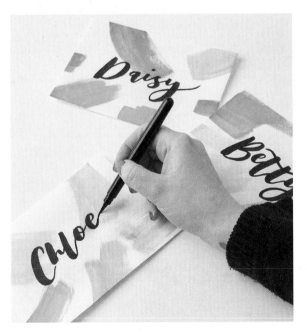

9. Once your envelopes are dry, they are ready for you to brush letter your names.

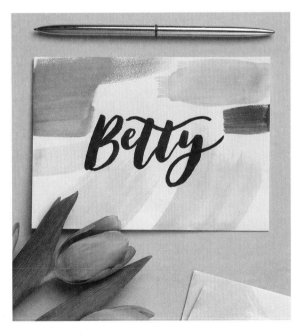

10. If you brush letter a whole address, make sure it's legible. You want it to be delivered!

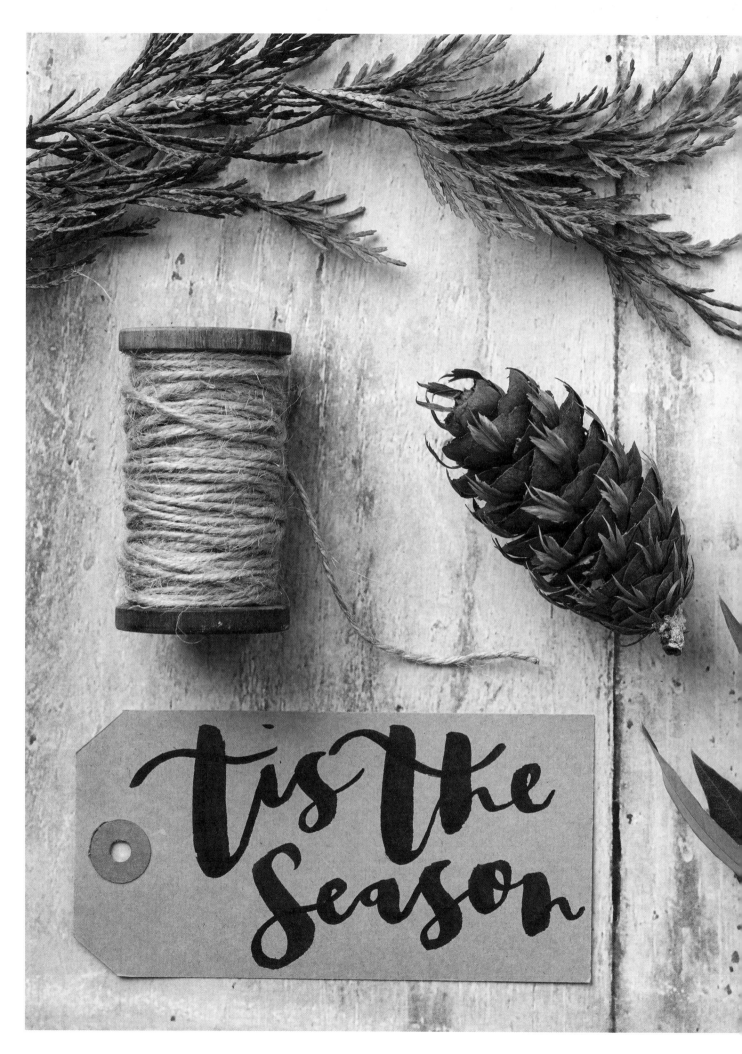

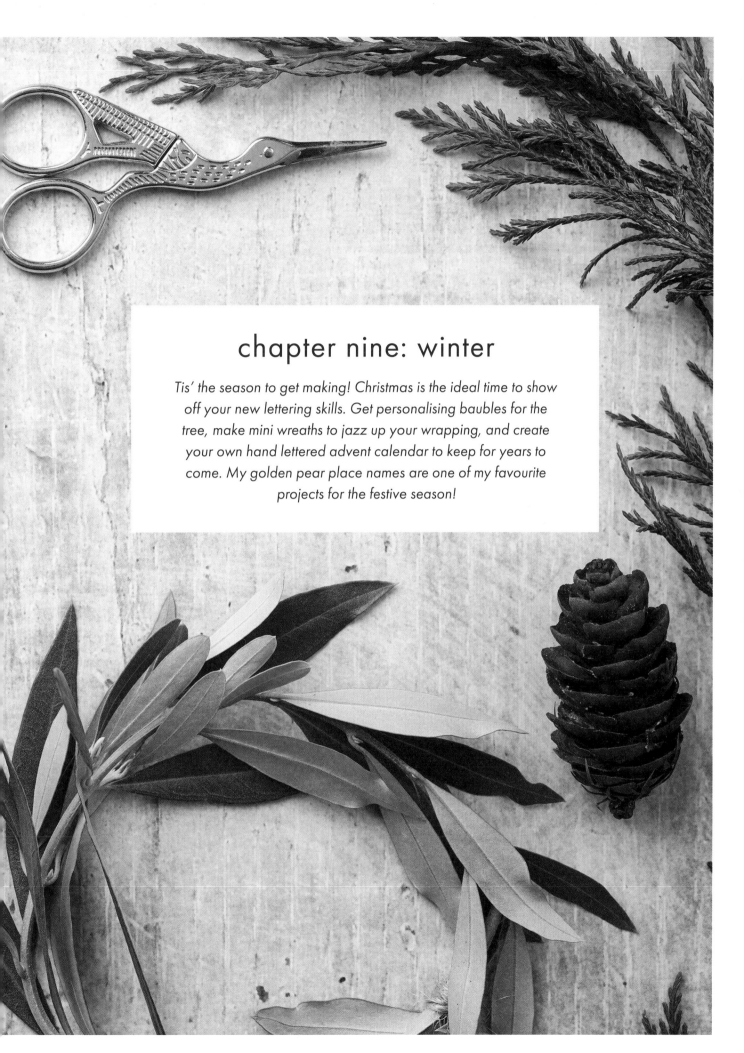

chapter nine: winter

Tis' the season to get making! Christmas is the ideal time to show off your new lettering skills. Get personalising baubles for the tree, make mini wreaths to jazz up your wrapping, and create your own hand lettered advent calendar to keep for years to come. My golden pear place names are one of my favourite projects for the festive season!

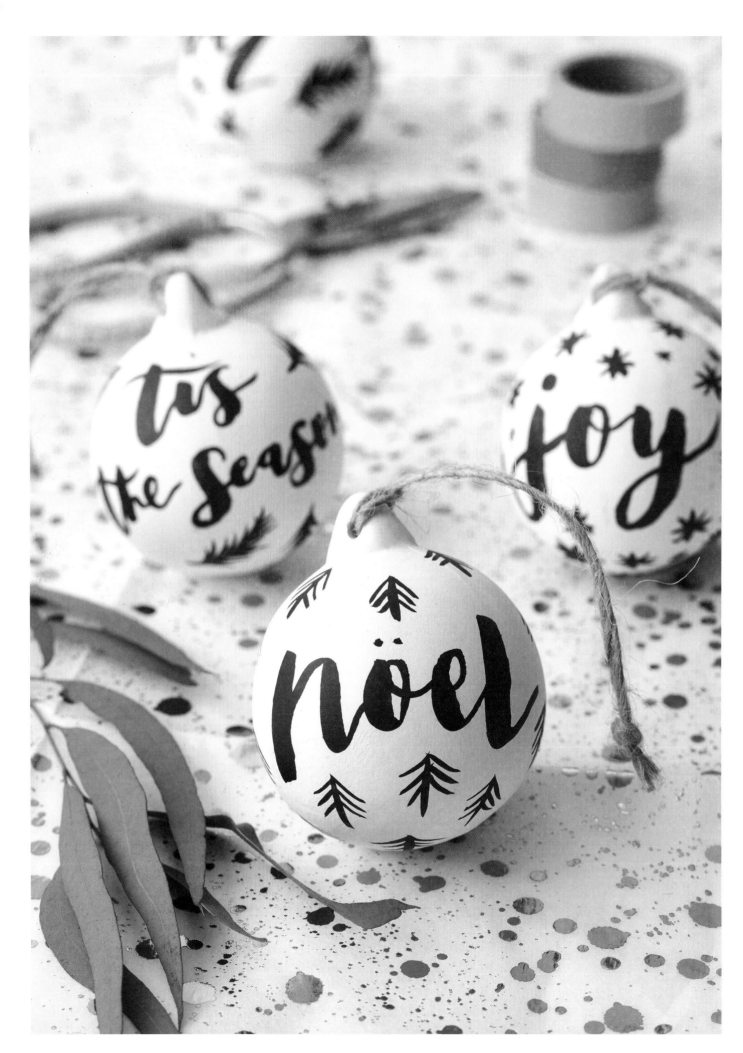

ceramic festive baubles

Buying a new decoration for the Christmas tree is a childhood tradition I treasure; every decoration holds a special memory. These baubles are a perfect family crafternoon project. Invite your loved ones round and sit down over a plate of mince pies and chocolate coins to create your own keepsakes for the tree.

Materials:
- Ceramic baubles
- Brush lettering pen

BECKI'S TIPS
- Add a layer of PVA glue to the bottom of the baubles and dip them into glitter. The sparkly bottoms will look beautiful on your Christmas tree.

- Look out for flat ceramic decorations. Stars, animals and tree shapes are good. You can also just cut shapes from thick card and decorate those. Punch a hole in the top and hang them up with some twine.

- Add colour with acrylic paint, paint pens or coloured markers for a kitsch colourful feel

- If you want to gift someone a bespoke decoration, letter their name on the bauble. You can also use them as table place settings.

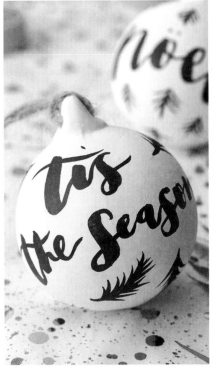
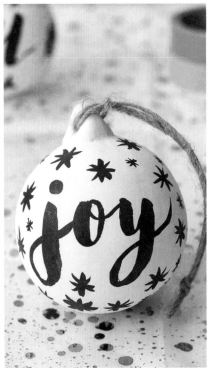

Making your own Christmas decorations is a great way to start the festive season. They are a lovely way to personalise your tree or home. Blank ceramic decorations are readily available in craft shops and are the perfect base for brush lettering and simple festive projects. In this project, I have created simple monochrome designs but this technique would work well with any colour combination.

1. Make sure the surface of the ceramic is clean before starting. Use a damp cloth to ensure there is no dust or marks on the surface.
2. Practice out your phrases on paper to give you an idea of size and placement on your bauble.

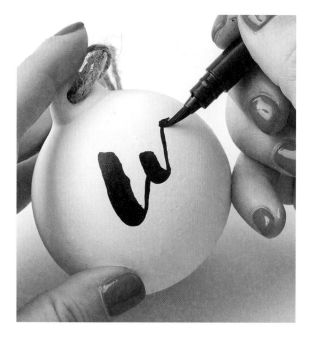

3. Use a pencil to rough out your wording before using a pen to letter across your bauble.

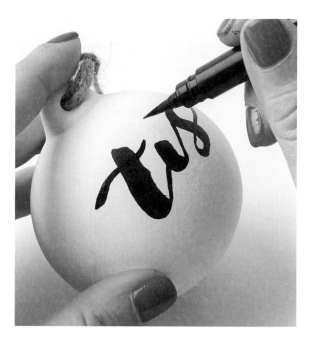

4. Lettering on a curved surface is more challenging than a flat surface so take your time.

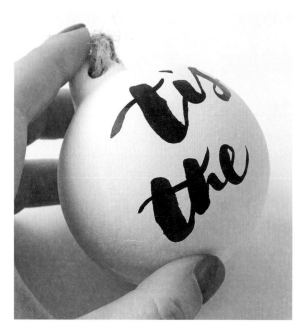

5. You can practice working on a curved surface by wrapping paper around your bauble and lettering.

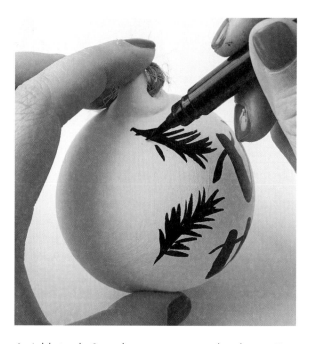

6. Add simple Scandi patterns using a brush pen. Try Nordic trees, stars, spots and foliage.

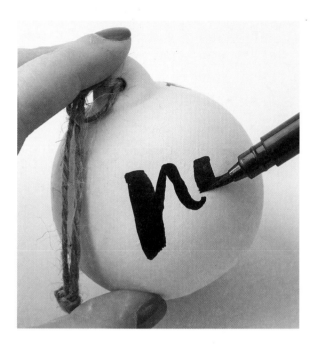

7. Creating tails on your letters will give you a chance to take breaks between making each letter.

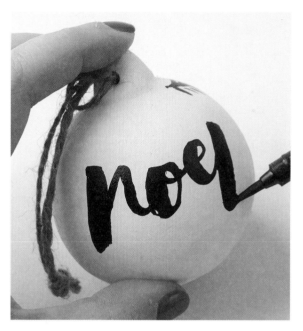

8. If you make a mistake simply paint over it with any acrylic or spray paint and start again.

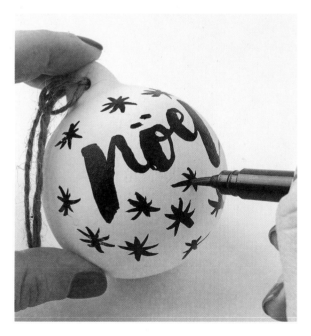

9. Create stars with line strokes joined in the middle using the tip of the brush and trees with line strokes.

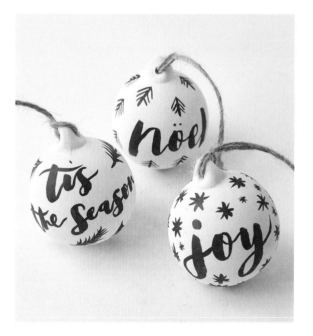

10. When the baubles are dry hang them on your tree with twine or ribbons. Happy Christmas!

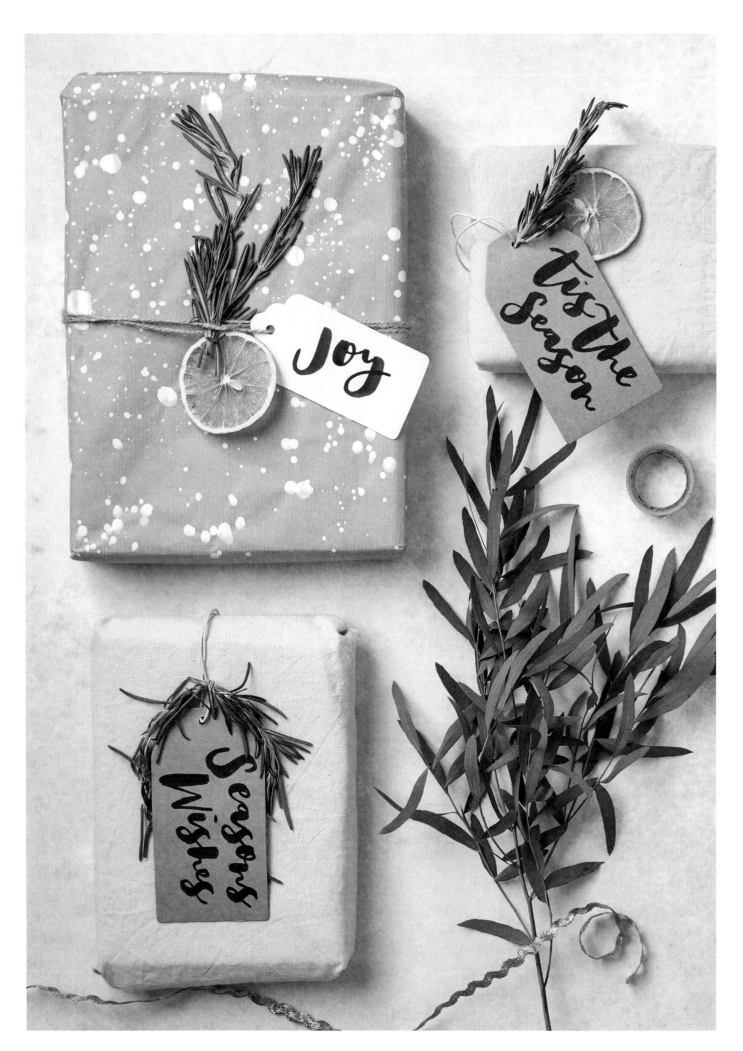

gift tags & mini wreaths

Making your own gift wrap and tags adds a lovely personal touch to your Christmas gift giving. This naturally-dyed and paint-splattered wrapping paper is easy to make and looks gorgeous paired with a mini wreath and brush lettered gift tag. Present wrapping becomes an afternoon of creativity.

Materials:

For the wreaths
- Floristry wire
- Fresh rosemary

For the gift tags
- Luggage tags
- Pens

For the paint wrap
- Kraft paper
- White acrylic paint
- Paint brush
- Water

For the fabric wrap
- Natural untreated fabric like linen, wool, silk or cotton
- Strawberries
- Water
- Big saucepan

BECKI'S TIPS
- Rosemary works well for the wreaths as the stems are fairly flexible.
- All varieties of eucalyptus look excellent!
- Avocado and other berries work as well as strawberries as blush dye.

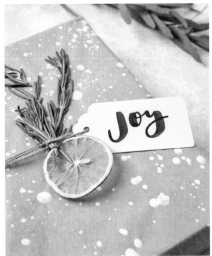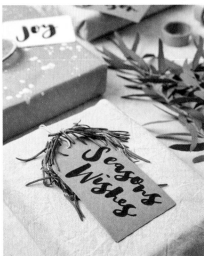

1. To make your own paint splattered wrap you just take a sheet of kraft wrapping paper and lay it flat on a table or flat surface. Mix some white acrylic paint with plenty of water so it will drip off your brush. Tap the brush across the paper to create a splattered look. Make sure you work on newspaper to protect your surfaces. Once you are happy with the paper, leave it to dry overnight.
2. To create your own natural dyed fabric, simmer a pan of chopped strawberries and water for about 1 hour. Strain the pan, throw away the strawberries and you'll be left with

your 'dye'. To dye your fabric, make sure its clean so the dye takes evenly. Put the fabric in the pan of dye and leave it to soak. For a soft blush pink, leave it for about 20 minutes. For a deeper shade of pink, leave it overnight. When you are happy with the colour, take your fabric out of the water and put it somewhere warm to dry - a radiator is perfect. The dye will not be permanent but used as a temporary wrapping cover it works perfectly. If you want your fabric dye to be fast, you'll need to use a dye fixative or mordant on your fabric so that it is washable.

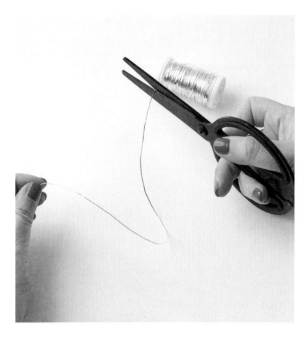

3. To create your mini wreaths you need to cut a length of floristry wire to form the frame .

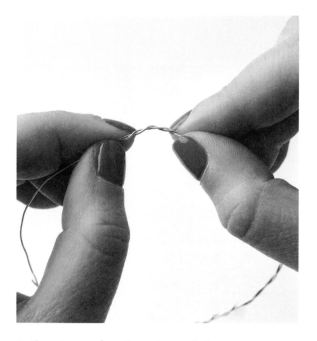

4. The wire is soft and can be easily bent into a circular shape the right size for your wreath.

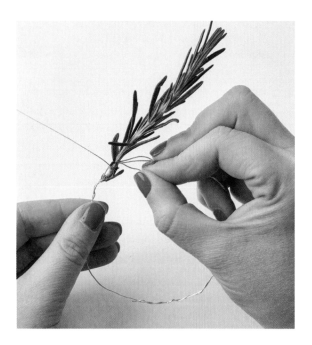

5. Twist and wrap rosemary around the wire securing the ends with extra wire to keep them in place.

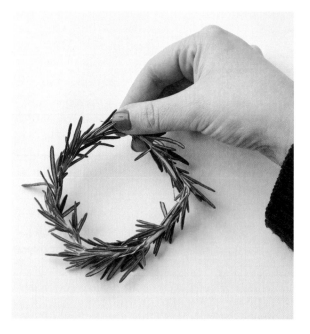

6. Cover the whole wire with the sprigs of rosemary. Don't worry if some wire is visible.

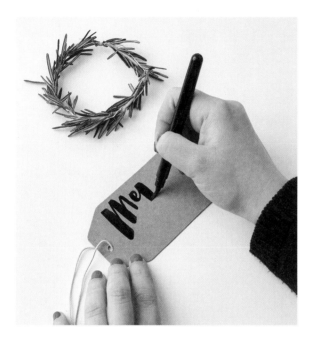

7. Rough out your gift tag lettering with a pencil before working over with a brush lettering pen.

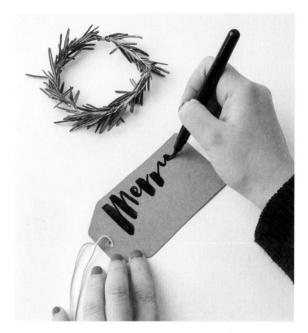

8. Brush letter your name or phrase on the gift tag - big bold phrases look great.

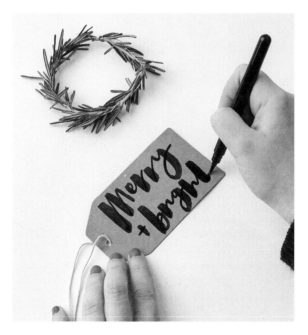

9. Secure the tag and wreath together using some gardening twine for a rustic effect.

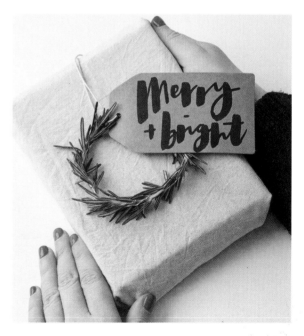

10. Secure you tags and mini wreaths to your chosen wrap to create a totally unique natural gift.

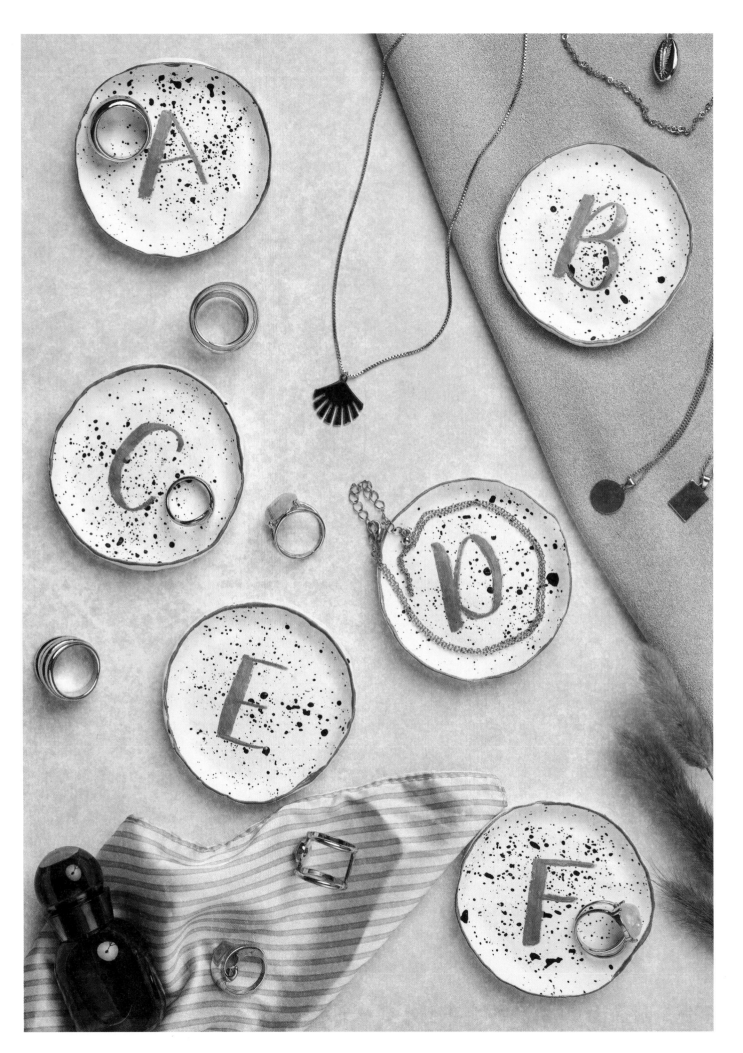

initial clay jewellery dishes

As soon as winter starts, the only thing on my mind is Christmas. I start thinking about ideas for gifts, wrapping and card ideas and I get obsessed with crafting during the festive season. These simple Fimo clay jewellery dishes are a wonderful idea for gifts for friends and family.

Materials:

▪ White Fimo clay

▪ Gold brush lettering pen

▪ Ink

▪ Paint brush

▪ Oven tray

▪ Oven

BECKI'S TIPS

▪ If you want to use coloured Fimo clay, think carefully about the legibility of your lettering.

▪ You can use a paint brush and acrylic paint to create your lettering if you don't want to use a metallic lettering pen.

▪ Try using cookie cutters to make fun-shaped dishes. I'm going to try shell shapes next.

▪ If you are making a few of these trays, make the golf ball shapes in one sitting so you can ensure they are all the same size.

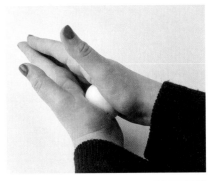
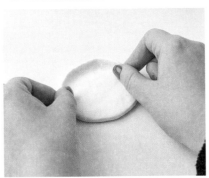
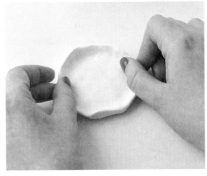

1. Unwrap your Fimo clay and warm it up in your hands. I chose white as my base for this project because I wanted a fresh look against my metallic lettering. Once your clay is warm, take a golf size piece of clay and starting working it in your hands. Make sure you work on a clean surface and wash your hands before you start as the clay picks up dirt very easily.

2. Press firmly to flatten the ball into in the palm of your hands, keeping the thickness of the clay even.

3. Once you have a flat shape for your tray, place it carefully on an even surface. Don't push down as Fimo is sticky and you won't be able to remove it easily. Now use your finger and thumb to pinch and pull the edges of the dish gently to create a rim for your dish.

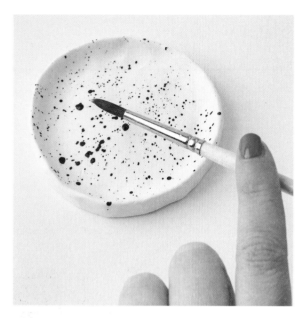

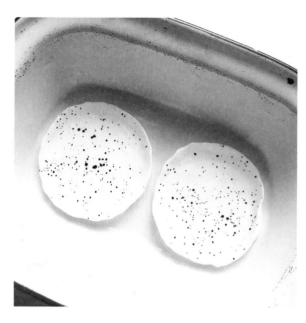

4. When you are happy with the shape of your dish, dip your paint brush into some ink and flick it over the dish. This will create the splattered effect.

5. Put your dishes on an overproof dish, making sure they aren't touching each other. Pop in the oven at 110°C/230°F for 20-30 minutes.

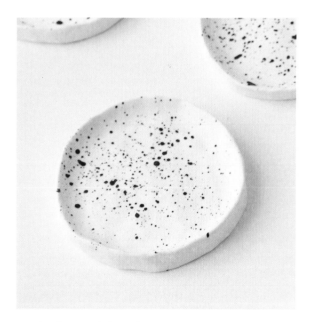

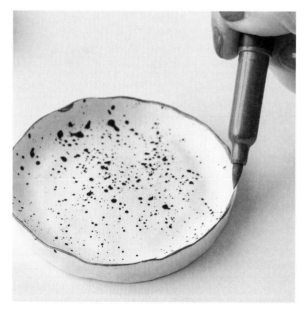

6. Check your dishes after 20 minutes. When they feel firm, then take them out to cool.

7. Give the dishes a gold rim using the nib of a metallic pen to work around the dish.

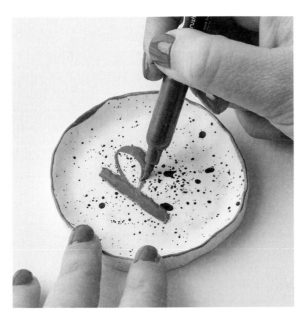

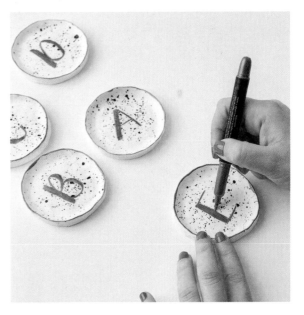

8. Sketch out where your letters will sit on the dish with a pencil. I created initial dishes for this project but you could letter phrases, names or numbers on your dish.

9. Use your gold brush lettering pen to carefully letter your initial on to the dish. Go over the letters again to make sure the letters are bold and eye-catching.

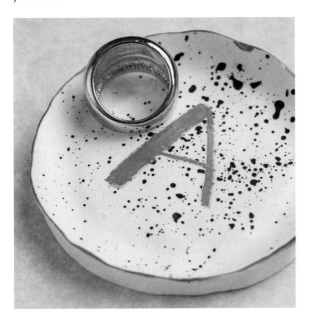

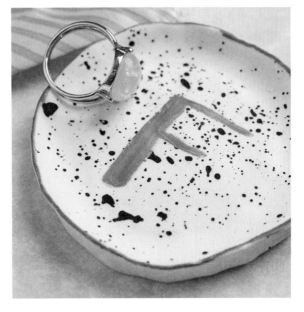

10. You can use a clear varnish over your dish to make them wipeable or leave unvarnished for a matte look.

These dishes work well for small bits of jewellery but you can use them for keys, coins or trinkets.

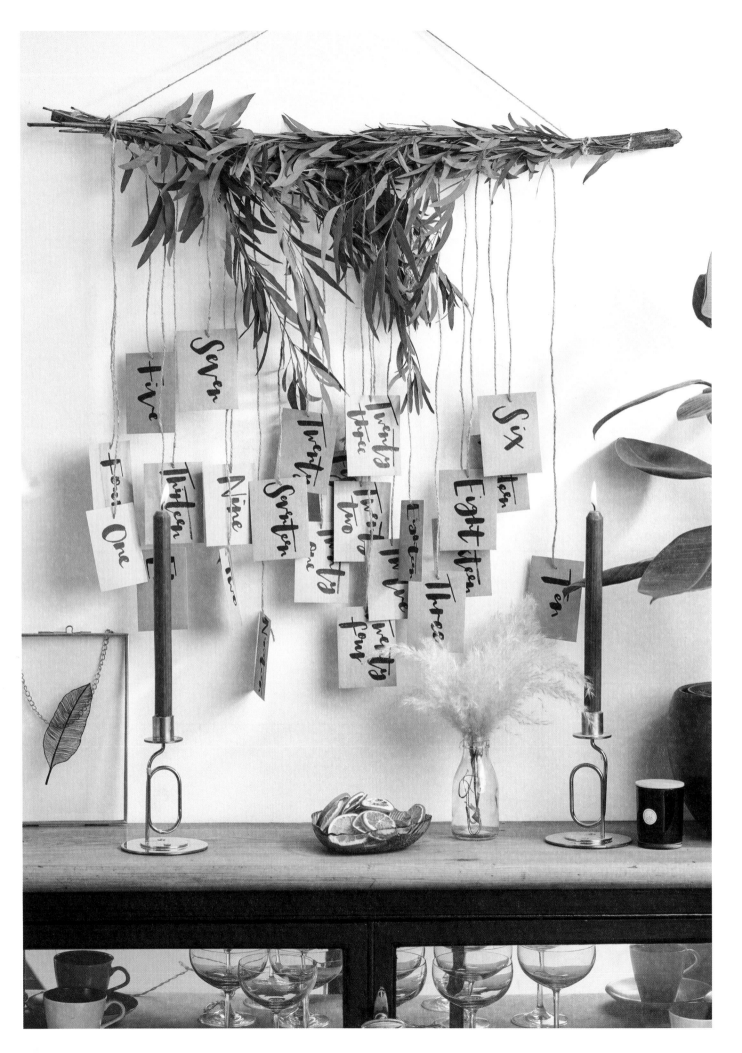

nordic inspired advent calendar

*This Nordic inspired advent calendar is one of my favourite seasonal projects.
You can fill the envelopes with something different every year so it will last
forever. It also doubles up as a wonderful festive decoration which you can hang
up in your house from 1st of December - and that suits me!*

Materials:
- Large branch
- Twine
- Mini envelopes
- A treat to fill your calendar with
- Pencil
- Brush lettering pen
- Foliage
- Hole punch
- Scissors

BECKI'S TIPS
- Make sure your branch is wide enough to fit 24 tags on. You don't want them to get tangled up.

- If you are short of time, you can replace words with numbers.

- String fairy lights through the branch to make it extra sparkly!

- Use luggage tags instead of envelopes and write lovely sayings on the back instead.

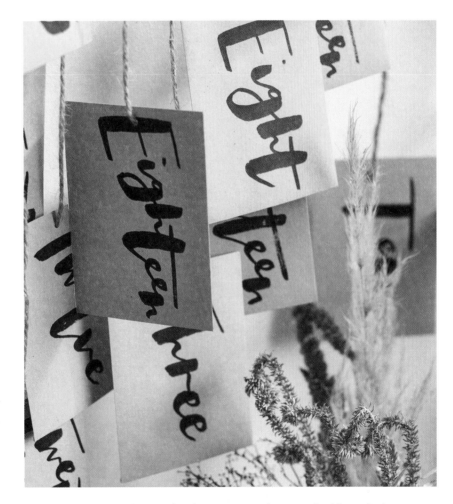

This brush lettered advent calendar is a great make you can reuse year after year. Pack it away carefully and the following Christmas, you can just replace the treats inside the envelopes. I also like to find new foliage to decorate the branch with. It also works well as a festive wall hanging; just add pretty baubles and extra decorations.

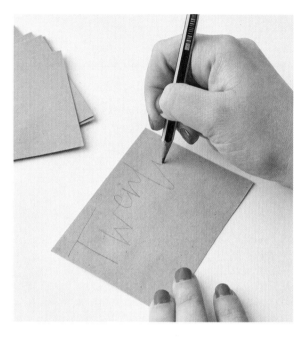

1. I used mini money wallets for this project as they are the perfect size and come in packs of 50.

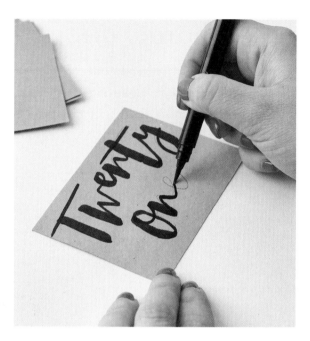

2. Use a pencil to rough out your letters and then carefully brush letter over them.

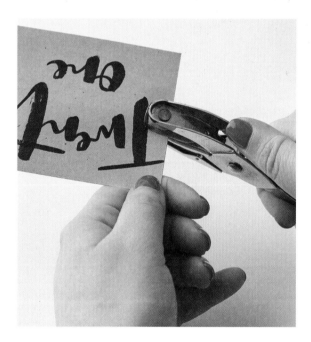

3. Once your lettering is dry, punch a hole in the top of each envelope using a craft punch.

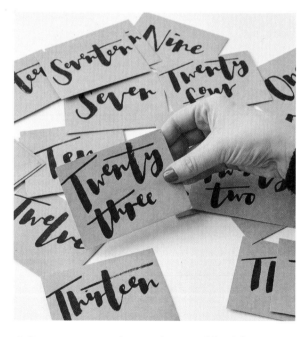

4. Pop your treat in the envelope and feed the twine through the hole so its nice and secure.

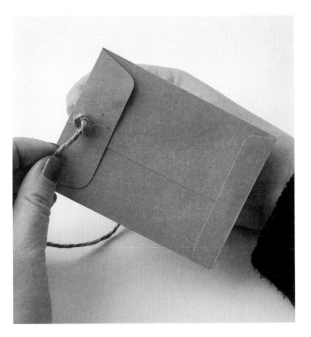

5. I like to vary the length of the twine so the envelopes hang at different lengths from my branch.

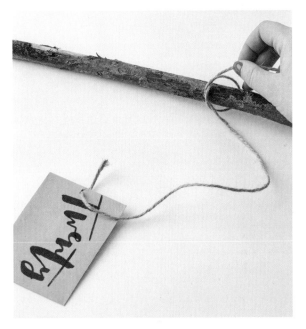

6. Tie the envelopes to the branch so they are evenly distributed along the length of the branch.

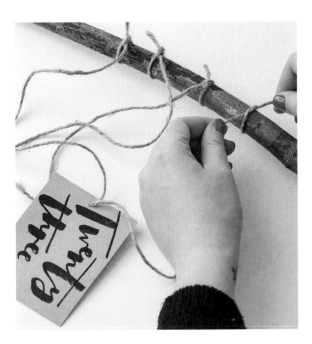

7. Snip any excess twine from your knots on the branch so that it looks neat and tidy.

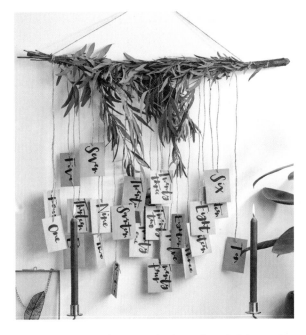

8. Now you can decorate the branch with foliage. I like eucalyptus, rosemary and lavender.

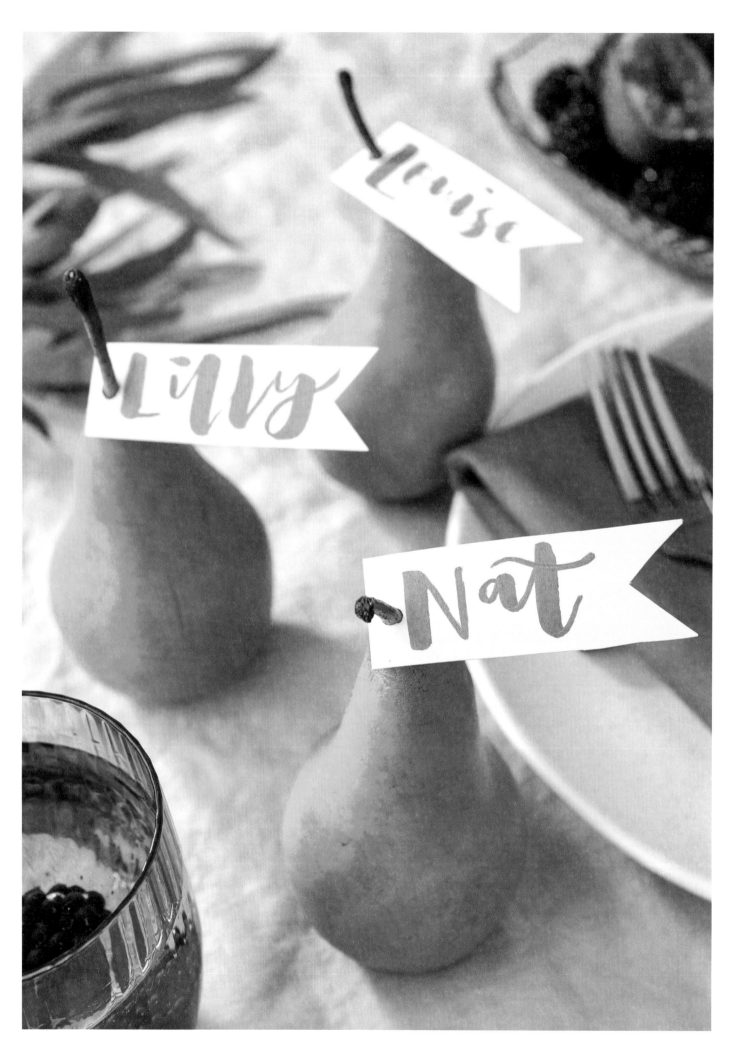

pear place names

This place setting idea came from my love of 'The Twelve Days of Christmas'.
Last year I thought how lovely it would be to use pears as Christmas Day table
settings. These golden pears have been painted with edible gold paint which
means you can eat them after they've been used as place settings

Materials:
- Pears
- Edible gold pen
- Card
- Scissors
- Hole punch
- Brush lettering pen

BECKI'S TIPS
- Pair with dark grey napkins and dark green foliage for a glamorous luxury table setting.

- If you like a more rustic look, white linen and paler green foliage and white flowers will look pretty with your gold pears.

- Metallic brush lettering looks great on dark colours, so look for look navy, black or deep burgundy card.

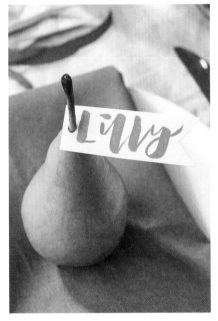

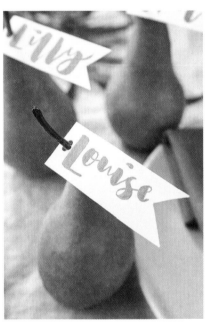

If you want to create your own gold pears, I suggest using an edible finish so you can eat them afterwards. You can find edible gold leaf, paint, metallic spray and glitter. Before you start painting your pears, make sure their skin is not broken and there are no bruises on them. I also make sure they are all the same size for a professional look. Then wash and dry them thoroughly, so they are clean and free of grease.

You can paint as much or as little of the pear as you like. I use a medium sized paint brush for maximum coverage. Leave the pears to dry while you work on your flags. If you are using paint I'd suggest leaving the pears to dry overnight. When they are dry, I love the idea of dipping the bottom of the pears in edible glitter or even creating painterly patterns across the fruit. For a different look, use other firm fruit like pomegranates or apples.

1. Start by taking your card and cutting out the flags. I used a 300gsm weight so it is nice and firm.

2. Cut out long rectangular shapes. If you want to save time you can buy the right sized pre-cut card.

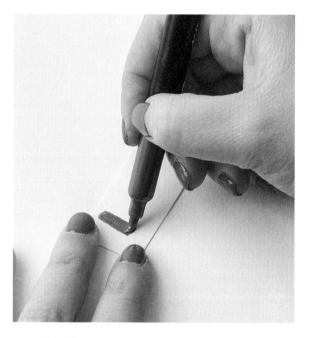

3. Create a mini flag shape by cutting a triangle out of one end of your rectangle.

4. Find the longest name on your list and letter this tag first. This will determine your lettering size.

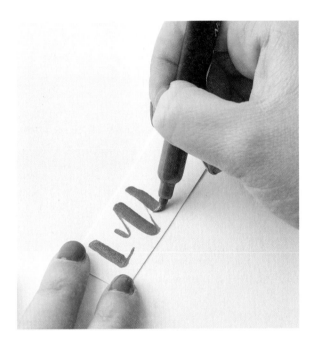

5. You want your tags to look consistent so shorter names will have more space showing on the tag.

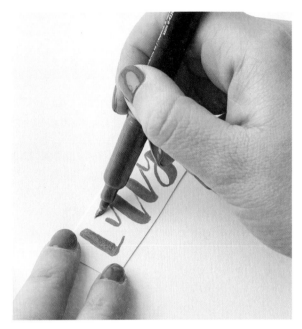

6. You can either create them all using the same colour ink or use a mix of metallics like I have.

7. Punch a hole through the opposite end of the tag to the flag shape using a single hole punch.

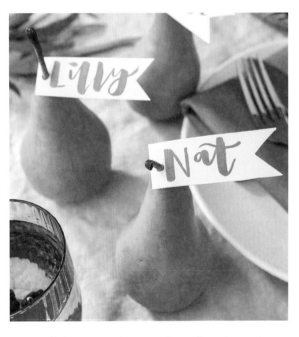

8. Attach the tags to the pears by pulling the stalk through the punch hole.

frequently asked questions

I'm left handed, can I still learn brush lettering?
Of course you can! Brush lettering is for everyone and there are some amazing left-handed lettering artists on Instagram and YouTube worth following for tips and tricks. I am right-handed so I have written and photographed this book from my view point. The best advice I can give left-handed letterers is to try and keep your grip in the middle of the pen to avoid smudging your letters as you work across the page. If you do this, you will be holding your pen away from the lettering. Don't feel restricted by your paper either; move it around to make it easy to work.

I have a wedding coming up and I want to learn brush lettering?
A special occasion like a wedding is a great reason to learn lettering. However, don't put too much pressure on yourself and give yourself plenty of time to learn. Practice a couple of times a week, working though my mark making exercises, alphabets, and practice phrases and you should feel confident in no time.

How long did it take you to learn?
I get asked this all the time! I think it only took me a couple of weeks to learn the basic techniques. I was then able to copy styles and phrases already lettered out for me and start to develop my own style. Finding my own unique style took longer - perhaps a year. Even now, seven years later, my style is still developing. I now provide hand-lettering to commercial clients and can offer them a huge range of styles and looks depending on the project. I still love to learn new tricks and tips and I really enjoy experimenting with different pens and materials to see how I can evolve my lettering.

Why does it look like my normal handwriting?
Don't worry! It will come. You have been hand writing for years and years and so there is a lot of muscle memory to unlearn. You are asking your hands to do something completely different. The most important skill in brush lettering is to learn to create different thickness strokes. Keep going back to your mark making techniques and working on getting a clear difference between your thick and thin strokes. That is the secret of brush lettering.

I've learnt calligraphy but want to try brush lettering? Will this give me an advantage?
They are not the same. The tools are different and there are very few similarities between brush lettering and calligraphy. If you have learned calligraphy, you will have a good understanding of letter forms and how to join your words but you will need to learn to hold your pen at a slant rather than upright.

What other surfaces can I brush letter onto?
Brush lettering looks great on so many surfaces, it's up to you to experiment. In this book there are lettering projects on card, glass, mirrors, ceramics, fruit, paper, terracotta, enamel, chalkboard and pumpkins! There are many other surfaces I love to letter on. Leaves make great place names, shells are wonderful with metallic lettering, pebbles and stones are lovely too. You really can letter on to anything - just make sure you have the right pen for the surface. The only important thing is to remember if you are going to be lettering on surfaces that food comes into contact with, you need to check your ink is food safe.

If you have any other questions then message me on Instagram @becki_clark_ and I will reply to you there.

stockists and resources

When I first began learning brush lettering, I had no idea what materials to buy or where to buy them from. It's not an expensive craft and you don't need much to get started; a basic lettering kit would include these materials.

Pens
- Pentel brush pen GFKP
- Docrafts Papermania metallic pens
- Docrafts dual-tip brush markers
- Kelly Creates brush lettering pens
- Posca paint pens

Inks
- Windsor & Newton Indian ink

Paints
- Windsor & Newton watercolour studio set
- Windsor & Newton gouache paint

Brushes
- Golden Taklon 10 pack brush set

Paper
- Layout paper

Other stationery items:
- Washi tape
- Twine
- Envelopes
- Card stocks
- Luggage labels and gift tags
- Kraft paper roll

My favourite shops to buy from:
Hobbycraft has an amazing range of brush lettering items. I also find their seasonal decorations are great to brush letter on; I particularly like their ceramic baubles for Christmas and mini Easter bunnies. Hobbycraft also stock a great range of cards, paper, brushes, washi tape and paper.

About the author

Becki Clark is a creative designer, inspired by nature and the changing seasons. She lives in the New Forest with her partner Nathan and their daschund, Reggie, who likes to keep Becki company in the studio.

After studying fashion at university, Becki went on to study graphic design. She then began working in the greetings card industry. Becki now works on a range of projects for different clients including print design, craft projects, prop making, editorial illustration and live illustration demonstrations for store openings and PR and influencer events. She also runs monthly brush lettering and botanical painting workshops, as well as running workshops for brands.

When she's not working on patterns, lettering and painting, Becki also runs a successful wedding stationery business, Olive and Bramble, which combines her love of all things floral with typography. Becki has worked for a diverse range of brands including Hobbycraft, The White Company, BBC Countryfile, Mollie Makes, Homesense and Soho House. When she's not working, you'll find Becki out in the forest walking Reggie and looking for new inspiration, reading, cooking or making flower displays around the home.

Acknowledgements

I would like to thank Katherine Raderecht for her amazing support throughout the process of making this book. When she got in contact with me in 2018 asking me if I'd like to work on a book I couldn't believe it! It was a dream come true. Thank you also to Hobbycraft for supplying so many of the materials that I've used in this book and to everyone on Instagram and in the craft world who cheered me on, and my lovely friend Lindsey for letting me use her house for some of the photographs. www.beckiclark.com @becki_clark_